IMAGES
of America

WAYNESBORO

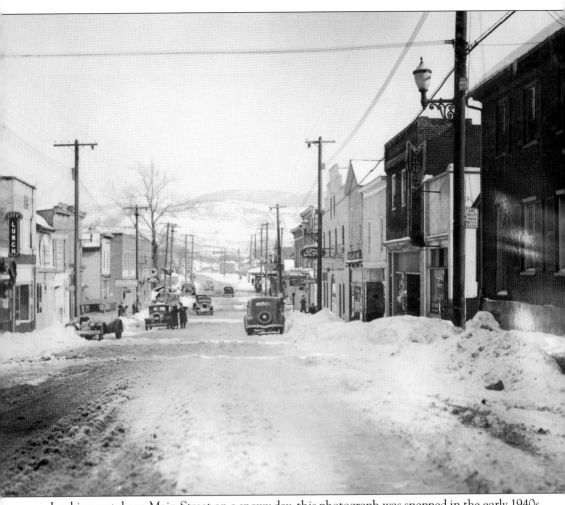

Looking east down Main Street on a snowy day, this photograph was snapped in the early 1940s. Downtown was a small but thriving business district. This block had several lunch establishments, the Fisher Bus Line, Wayne Welding Company, the Cavalier Theater, Wayne Motor Sales, Michael's Auto Top Shop, the Main Street Service Station, and more. The building on the close right is the 1806 Coiner-Quesenbery House. (Photograph by R. L. Hiserman; courtesy Ron Hiserman.)

IMAGES

of America

WAYNESBORO

Elizabeth Spilman Massie
and Cortney Skinner

ARCADIA
PUBLISHING

Published by Arcadia Publishing
Charleston SC, Chicago IL, Portsmouth NH, San Francisco CA

Printed in the United States of America

Library of Congress Control Number: 2008940557

For all general information contact Arcadia Publishing at:
Telephone 843-853-2070
Fax 843-853-0044
E-mail sales@arcadiapublishing.com
For customer service and orders:
Toll-Free 1-888-313-2665

Visit us on the Internet at www.arcadiapublishing.com

*This book is dedicated to Anya, Elliot, Cory, and Dixie,
and to the next generation of Waynesborians.*

CONTENTS

ACKNOWLEDGMENTS

It is incredible how much history a small city has. To tell the complete story of every business, industry, church, school, event, and person that played a part in the development of even the smallest community would take a lifetime or more. Waynesboro's population to date is around 20,000. During the first 100 years of its history, its population grew to only 2,500. Yet during those first years and since, much has been accomplished, and much has transpired. A story of a people and a place has evolved. We want to acknowledge those who have spent tireless hours collecting and preserving the history of Waynesboro as each new bit of information comes to light and those who have made it possible for us to offer this sampling of the Waynesboro experience. These include Shirley Bridgeforth, Courtney Gondoli, and Clover Archer of the Waynesboro Heritage Foundation and Museum; Karen Vest of the Waynesboro Public Library; historians and authors George R. Hawke and Curtis Bowman; Ron Hiserman; Estello Randolph of the Waynesboro African American Museum; Nita Bellamy; Patricia Black Spilman; Eugene C. Perry Jr.; the Tree Street Neighborhood Association; Clair Myers and Courtney Ledbetter of the Wayne Theatre Alliance; Rick Moyer of Waynesboro Downtown Development, Inc.; Kevin Blackburn; Betty Lewandowski of the Augusta County Historical Society; Joe Moyer; George Robertson; Barbara Spilman Lawson and Charlie Lawson of the Waynesboro Players; Catherine VanPatten; Liz Bowles; Joe Morse; J. B. Yount III; John Trissel; Crystal and Chris Graham; Steven Paige Holder; Mark Kearney; the *News-Virginian*; and Kin and Debbie Yancey. We would also like to thank our editor at Arcadia Publishing, Brooksi Hudson, for her guidance, patience, and kindness.

INTRODUCTION

Waynesboro, nicknamed the "River City" because of the South River that meanders throughout it, sits in the heart of Virginia's Shenandoah Valley, at the eastern edge of Augusta County and at the foot of the Blue Ridge Mountains. The city was settled by German and Irish immigrants who came "up the Valley"—meaning south, as the rivers ran northward and the settlers traveled "up river" to move south—from Pennsylvania in the mid-1700s. Waynesboro was originally called "Teesville" after the Joseph Tees (Teas) family that settled there and after the rustic Tees' Tavern that Mary Tees operated in the late 1770s and 1780s.

In 1797, James Flack bought four parcels of land in Teesville and, with the help of Samuel and Jane Tees Estill, divided the land into lots and began to promote the area to encourage more settlers. The town's name was changed to "Waynesborough" after Gen. "Mad" Anthony Wayne, a Revolutionary War hero from Pennsylvania. Waynesboro grew slowly through the first half of the 19th century, its population remaining in the hundreds. The 1810 census gave the population as 250. In 1860, it had only grown to 457. Waynesborians raised corn, hay, wheat, and flax, as well as animals, some of which they used themselves, while some they sold and shipped east and north. Others built furniture and carriages and milled grains. The first post office was established in 1802, and the first circulating library opened in 1817.

The Civil War did not pass Waynesboro by. On March 2, 1865, Union general Philip Sheridan's men engaged Confederate general Jubal Early's men in Waynesboro for a short yet devastating battle. More than 1,000 Confederate soldiers were taken captive by the Union army.

As the South began to recover following the war, industry developed in Waynesboro. Some of the earliest industries included the Alexander Furniture and Casket Factory, the Loth Stove Factory, Lambert Brothers lumber, and the Rife Ram and Pump Works. The town established its first fire department in 1893.

By 1881, a north-south railroad connection linked Roanoke in the southwest to Hagerstown, Maryland, in the northeast. Along with the already-established east-west railroad that crossed the mountain through the Blue Ridge Tunnel, this made the area a major junction, bringing more people and goods to and through town.

Speculators founded and incorporated Basic City in 1890. Situated at the crossing of the Norfolk and Western (N&W) and Chesapeake and Ohio (C&O) rail lines, Basic City sat immediately across the South River from Waynesboro to the east. A brochure touted the natural resources, clean water, and balmy air of the area. From the beginning, Basic City was envisioned and promoted as an industrial center. Unfortunately, the reality did not live up to the promotion. Quite a few of its industries failed in the wake of the depression of 1893. This included the Dawson Manufacturing Company, the first company to build an automobile—the Dawson—in Virginia; it was also one of the few steam-driven cars ever made in America. Some industries were successful, if only for a short while. Yet others held on and succeeded. Basic City became known for its hotels, which

offered retreats in the warmer months. In spite of those who fought against the idea for reasons of money and civic pride, Basic City and Waynesboro were consolidated in 1924.

Waynesboro thrived as a manufacturing town during the early to mid-20th century. One major industry was DuPont, the textile manufacturer, which set up business in 1929. It remained a major employer until 2004, when DuPont Textiles and Interiors became Invista. Waynesboro was also home to the Crompton-Shenandoah Company, General Electric, Virginia Metalcrafters, Basic-Witz Manufacturing Company, and others. Apples were another thriving industry, with numerous orchards surrounding the town and planted along nearby mountain ridges. Apples grown in Waynesboro orchards were packed, stored, and shipped by rail. Early Dawn Co-op Dairy bottled and delivered milk by truck and horse-drawn wagon.

Waynesboro's downtown, initially covering just four square blocks, became a bustling area. Clothing stores, furniture stores, shoe stores, drugstores, hardware stores, banks, and department stores, as well as eateries and two movie theaters, drew in customers from town as well as from outlying Augusta County. More businesses soon expanded beyond the downtown area.

Close-knit families tended to stay in Waynesboro, taking advantage of the schools, churches, and recreation available. New families came to town to work at DuPont, General Electric, Virginia Metalcrafters, and other factories.

Flooding of the South River has long been a problem for Waynesboro. Some of the worst have caused major damage to businesses and homes in the low-lying areas. The most severe floods occurred in 1936, 1942, and 1969, with other seasonal flooding an ordinary occurrence. The city continues to struggle with the power of nature and the tendency for the river to venture well beyond its banks.

The Blue Ridge Mountains have a powerful, historic link to Waynesboro. The apple industry flourished in the mountains as well as in Waynesboro in the late 1800s and early 1900s, and the apples were brought into town for storage, processing, and shipping. The Shenandoah National Park and Blue Ridge Parkway, established in the 1930s, increased the number of tourists to Waynesboro. The Appalachian Trail, completed in 1937, passes by Waynesboro to the east, and Waynesboro's post office serves as a major mail drop for hikers. Mountain arts and music were and remain popular in Waynesboro.

From the "Academy," built in 1832, to the present-day public high, middle, and elementary schools, Waynesboro has put education in the forefront. Fishburne Military School was founded in 1882 and remains an accredited school today. Fairfax Hall girls' school was established in 1920 in what had been the Brandon Hotel and educated girls until 1975. The current Waynesboro High School was built in 1938 and Kate Collins Junior High School in 1963. Rosenwald School, Waynesboro's African American school, was built in the late 1920s as part of a project funded by philanthropist Julius Rosenwald. Waynesboro's Rosenwald School closed in June 1966 when Waynesboro schools integrated, 12 years after *Brown v. Board of Education*.

With the closing of a number of industries in the mid- to late 1900s, Waynesboro began to focus on and draw upon the natural beauty of its location, its historic and cultural uniqueness, and the artistic talents of its citizens to strengthen and redefine the city as it moved into the 21st century. While it remains a "working city," it also now highlights the creativity and friendliness that have always been there to encourage citizens to stay and tourists to visit. The Shenandoah Valley Art Center, the Waynesboro Players, the Waynesboro Cultural Commission, the Waynesboro Downtown Development, Inc., the Waynesboro Heritage Foundation, and other organizations demonstrate this commitment. Events such as the Fall Foliage Festival Art Show, Riverfest, the Virginia Fly Fishing Festival, and more help Waynesboro to live up to its slogan, "Hospitality in the Valley."

One

EARLY DAYS

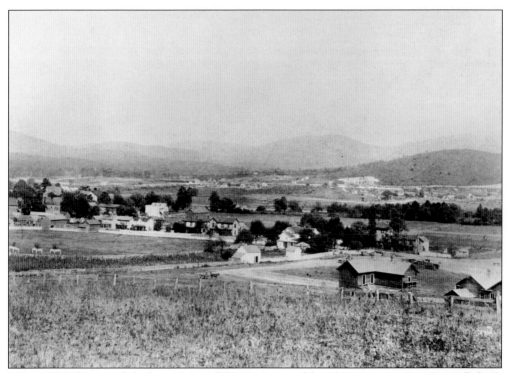

This c. 1890 photograph looks east toward Wayne Avenue (above) intersecting First Street (below). The Fishburne Military School field, delineated by the white fence, is on the left. The white building with the dark roof to the left of center on Wayne Avenue is thought to be the Valley Seminary, built in 1888. The roadbed of the Chesapeake and Ohio Railway extends across the left center in the distance. (Courtesy Waynesboro Public Library.)

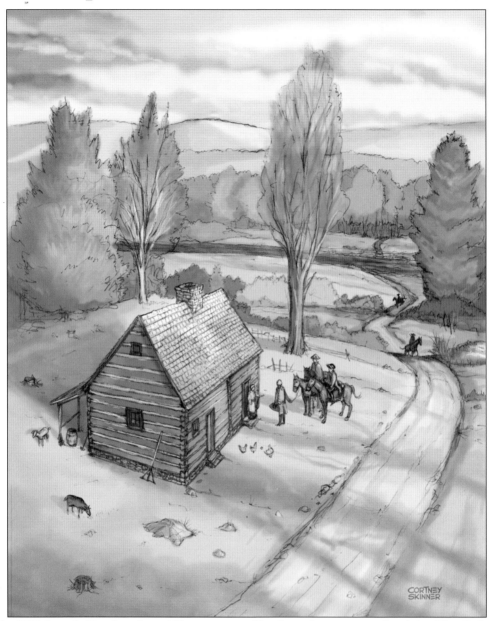

In 1739, Joseph Tees bought a 465-acre tract of land on the western side of the Blue Ridge Mountains near the trail that connected Rockfish Gap with Beverley's Mill Place (now Staunton). He purchased additional adjacent tracts until his death in 1755. Tees bequeathed the land to his sons, William and Charles. William and his wife, Mary, built a cabin on their land, and when widowed, she converted the cabin into a tavern. The settlement that grew around it was called Teesville and, later, Waynesboro. In 1782, the Marquis de Chastellux, who fought in the Yorktown campaign of 1781, visited "Widow Tees' Tavern." The location, while not exactly known, was "200 paces from the ford" of the South River, according to the marquis. It is not known how the tavern looked, but this artist's conception shows a typical Midland log house, originally with a gable end chimney but with an addition that doubled its size, characteristic of lodgings in the valley at this time. (Illustration by Cortney Skinner.)

Waynesboro was named after Revolutionary War general Anthony Wayne. Born in 1745 in Chester County, Pennsylvania, Wayne began his military career in 1776 as a colonel of the 4th Pennsylvania Battalion. He moved quickly through the ranks. Skilled and hot-tempered, he earned the nickname "Mad" Anthony. Though Wayne never lived in Virginia, he was a hero to Pennsylvanians who settled the town. "Waynesborough" was recognized by the state government in 1801. (Courtesy Waynesboro Heritage Foundation.)

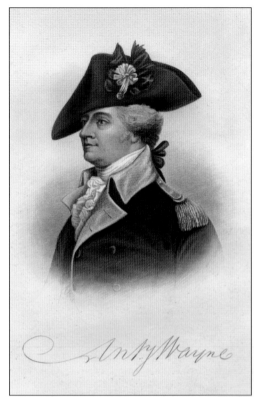

The *c.* 1880 photograph below shows Waynesboro looking southeast from near the Florence Avenue Bridge. Visible slightly left of center is the old Chesapeake and Ohio train station between Ohio and Mulberry Streets. The two large buildings to the left behind the station are Lambert Manufacturing and Ellison's Hay Compress. The building in the foreground is the freight depot. (Courtesy Waynesboro Public Library.)

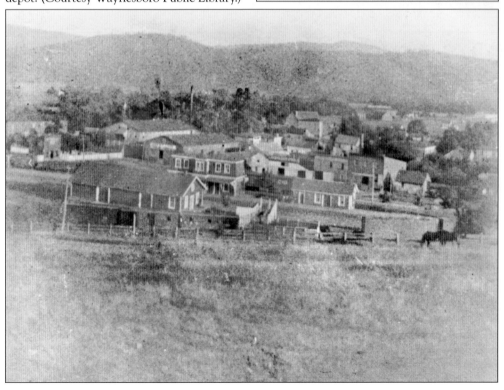

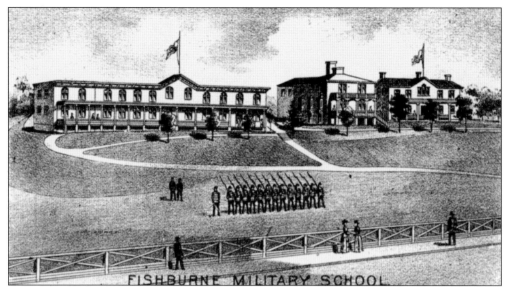

Fishburne Military School remains an educational institution and historic landmark. James A. Fishburne, the school's founder, was the son of Daniel Fishburne, who moved to Waynesboro in 1819. After graduating from Washington College (now Washington and Lee) in 1870, James Fishburne returned to Waynesboro to teach at the town's Academy. In 1882, he established his own school several blocks away on South Wayne Avenue. This is a detail from an 1880s-period map. (Courtesy Waynesboro Heritage Foundation.)

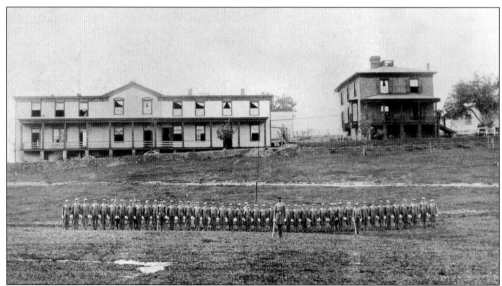

This late-1880s photograph shows Fishburne Military School cadets on the drill field. Behind them is the frame barracks on the left and the principal's house on the right. There were about 50 cadets enrolled by 1886, and enrollment continued to grow quickly over the years that followed, necessitating the enlargement of the barracks three times before the current brick barracks was constructed in 1917. (Courtesy Waynesboro Heritage Foundation.)

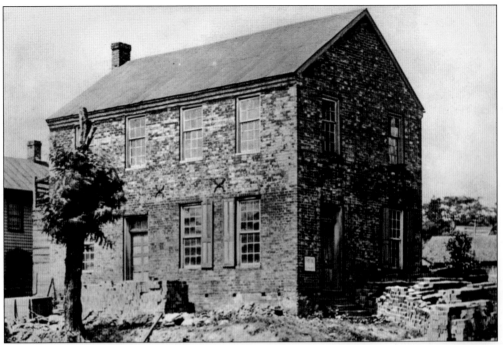

The Academy, located at the corner of North Wayne Avenue and Mulberry (now Broad) Street, was built in 1832. It served as a public school as well as a town hall and civic center. During the Civil War, the building was used as a hospital. James A. Fishburne reopened the Academy following the war. The school closed permanently prior to 1890, and the building was demolished. (Courtesy Waynesboro Heritage Museum.)

The oldest frame dwelling in Waynesboro is the Plumb House, built between 1802 and 1804. The Plumb family moved into the house in 1837. During the Civil War, the house was caught in the middle of the Battle of Waynesboro on March 2, 1865. The City of Waynesboro purchased the house in 1994. It is now maintained by the Waynesboro Heritage Foundation. This photograph is dated 1870. (Courtesy Waynesboro Heritage Foundation.)

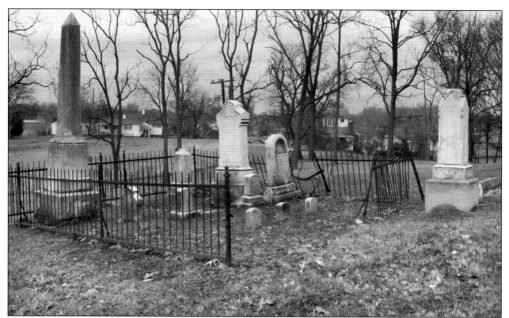

Presbyterian Cemetery, situated between New Hope Road and Ohio Street, is the burial place for 25 Civil War veterans and other persons of military, civic, and religious note. The first burial was recorded in 1815, though the graveyard may have been used as early as the late 18th century. In 1934, the cemetery became the property of the city. Masons' Hall is visible behind the cemetery right of center. (Photograph by Cortney Skinner.)

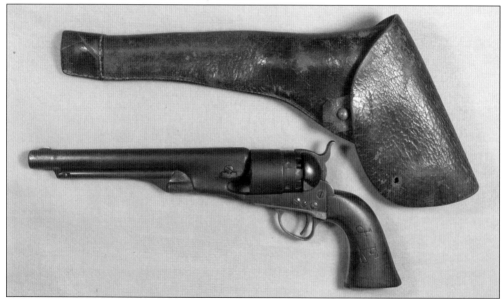

Confederate general Jubal Early commanded the troops during the Battle of Waynesboro on March 2, 1865. The Confederates were quickly defeated by Union brevet major general George A. Custer, with more than 1,000 Confederates captured. This photograph shows a Colt Model 1860 Army Revolver that belonged to Jubal Early, with the initials "J. E." carved into the wooden grip. According to Samuel Black family history, Early gave the weapon to Samuel in 1862. It now belongs to Patricia Black Spilman. (Photograph by Cortney Skinner.)

Members of the Coyner (Coiner) family have been Waynesboro residents since the late 1700s. In 1806, Caspar and Margaret Barger Coyner built their brick home on West Main Street, which still stands as the Coiner-Quesenbery House. This photograph, taken October 19, 1892, shows Coyner relatives who gathered for a family memorial dedication. Simon Coyner, son of Caspar and Margaret, is on the right. He was 97 at the time. (Courtesy Waynesboro Heritage Foundation.)

In the mid-1700s, Augusta County was one of the American colonies' largest counties, reaching north to the Great Lakes and west to the Mississippi River. Beginning in 1769, other counties were created from the expanse of land and, later, six other states. Situated in eastern Augusta County, Waynesboro has always been closely tied to the county's agricultural, business, and social goings-on. The Augusta County Fair has been a prominent event for well over 100 years. (Courtesy Waynesboro Heritage Foundation.)

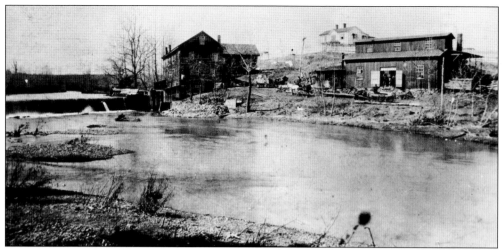

George Schoppert and his son-in-law William Alexander Rife moved to Waynesboro around 1880 and built the Rife Ram and Pump Works beside the South River. By 1884, the foundry was producing hydraulic rams and iron stoves. This *c.* 1895 photograph shows the original log and stone dam and pump works buildings. In the 1920s, Rife Ram and Pump Works became part of Rife-Loth Corporation, which later became Virginia Metalcrafters. (Courtesy Waynesboro Heritage Foundation.)

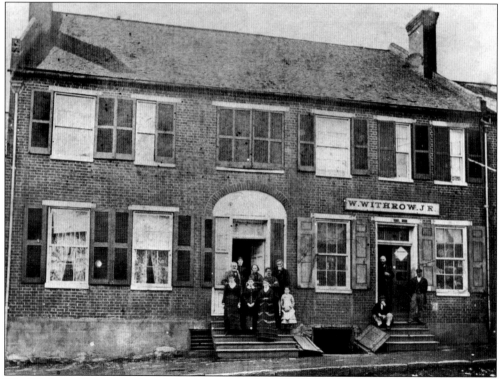

The Withrow House stood on West Main Street in downtown Waynesboro in the spot where Main Street Discount is currently located. William Withrow and his family moved into the house in the 1850s. They were active with the local Presbyterian church. This 1882 photograph shows members of the Withrow family in front of their home. (Courtesy Waynesboro Public Library.)

In 1838, Daniel Fishburne purchased land on the northwest corner of Main Street and Wayne Avenue and opened a general store two years later. The building was partitioned for the business and the family's living space. In 1878, Daniel's son Elliott (brother of James A. Fishburne, who founded the Fishburne Military School) and Dr. J. S. Myers converted the business to a drugstore. This 1888 photograph shows the store on the right and family residence on the left. (Courtesy Waynesboro Public Library.)

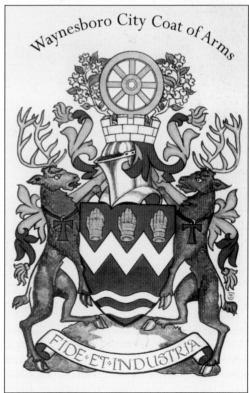

Waynesboro's coat of arms features symbols particular to the city. The motto "Fide Et Industria" translates to "By Faith and Industry." The shield bears a zigzag pattern that incorporates both a "W" for Waynesboro and a "V" for Virginia. The wheel and dogwood atop the crest represent Waynesboro's role as the "hub of scenic, historic, and industrial western Virginia." The coat of arms was commissioned by the Waynesboro Heritage Foundation. (Courtesy Waynesboro Heritage Foundation.)

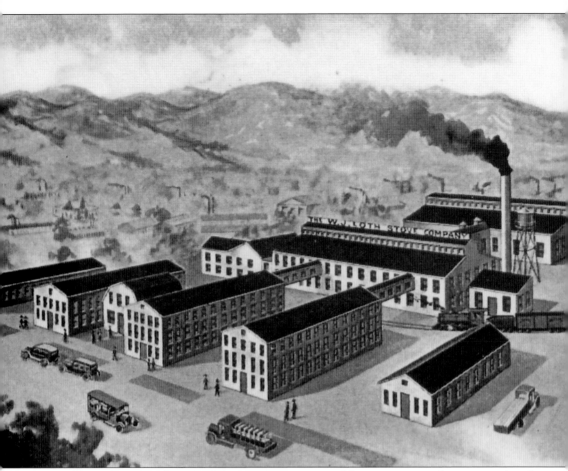

William Jefferson Loth, a Confederate army veteran and former prisoner of war, secured a job at a stove factory in Richmond in 1865. Then, with the engineering knowledge he had gained, he moved his family to Waynesboro, where he founded his own stove company in 1890. The W. J. Loth Stove Company produced first wood, coal, and gas stoves, and eventually electric stoves. It also did foundry work. William's son Percy took over the business when his father died in 1904. Another son, Francis Loth, became Waynesboro's mayor in 1948. A third son, Carl C. "Rip" Loth, established the city's Valley Airport. Loth Stoves and the Rife Ram and Pump Works merged around 1935 to form the Rife-Loth Company. This 1923 catalog illustration shows the factory, which was located between Arch Avenue and South River. (Courtesy Waynesboro Heritage Museum.)

Two

A TALE OF TWO TOWNS

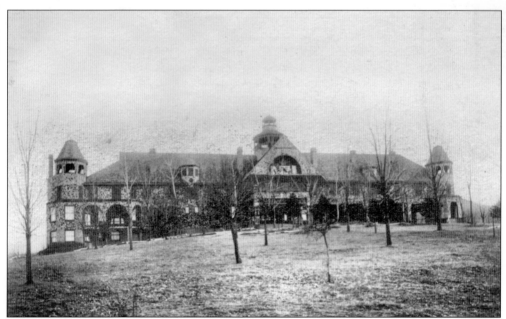

Built on a speculation of wealth from industry and tourism, Basic City was created by investors and incorporated across the South River from Waynesboro in 1890. The town promised jobs in industry for citizens and healthful leisure for tourists. This postcard shows the Hotel Brandon, which was built in 1890. It boasted "eighty large, well-furnished rooms" and "free use of the famous Basic Lithia Water." (Courtesy Waynesboro Public Library.)

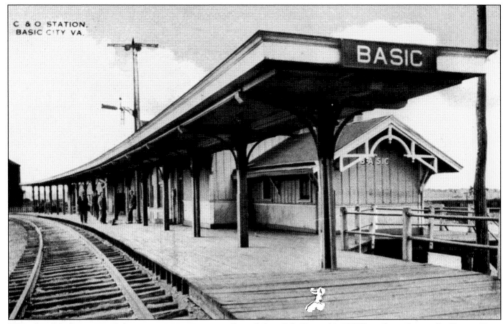

The establishment of the crossing train tracks of the C&O and N&W railroads made Basic City a hub of activity, bringing mail, goods, and travelers to town. This *c.* 1923 photograph of the Chesapeake and Ohio station on Sixth Street shows the station proudly bearing the name "Basic," just before the consolidation that merged Waynesboro and Basic into a single city. (Courtesy Waynesboro Heritage Foundation.)

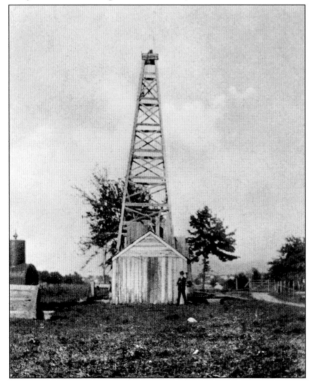

Within a year of Basic City's incorporation, several geologists suggested there might be oil in the area. The Basic City *Advance* declared, "There's millions in it." However, Basic City mayor Jed Hotchkiss believed there was no oil. Drilling began on land that was later sold to DuPont. Artesian water was found but not oil, and the well was abandoned. Another drilling effort took place in 1902, but that also came up short. (Courtesy Waynesboro Public Library.)

Numerous industries were established in Basic City, but with the depression and panic of 1893, some quickly faltered. During the four years that followed, commercial institutions closed, and at least two banks floundered. Basic City Bank survived into the first quarter of the 20th century. This *c.* 1920 photograph shows bank employees John Rixie Smith, cashier, and Iva Hall, bookkeeper. (Courtesy Waynesboro Heritage Foundation.)

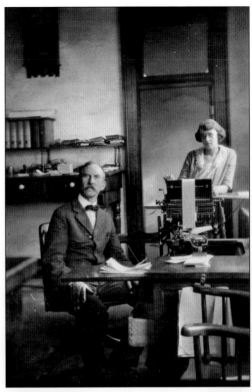

The Iron Cross Bank was located at the corner of Bayard Avenue and Fourth Street, as shown in this 1895 photograph. The name "Iron Cross" came from the two crossing railroad lines in Basic City. The original building on Bayard Avenue still stands. (Courtesy Waynesboro Public Library.)

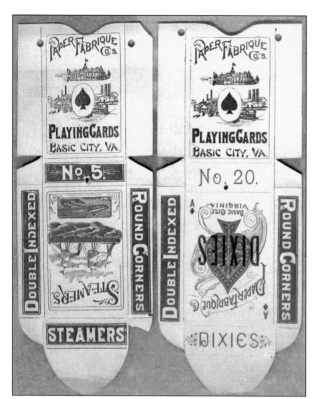

One hopeful Basic City industry was the Paper Fabrique Company, which opened for business in March 1891. It was situated near the train tracks where Fifth Street dead-ends. Paper Fabrique produced cardboard, paper, and playing cards. The company did not last long, however. The building was soon converted into a gristmill, a blanket factory, and then a shirt factory. It burned soon thereafter. (Courtesy Waynesboro Heritage Foundation.)

Basic City was home to a bold new venture—automobile manufacturing. The Dawson Manufacturing Company was established in 1900 and produced just one car, a Dawson steam-powered automobile. The car had a single chain drive and a two-cylinder engine. George Dawson, the factory's owner, tried to sell the car by advertising in trade journals with no success. He finally sold the car to Luther Gaw and John Clark of Waynesboro and was built no more. (Courtesy Waynesboro Public Library.)

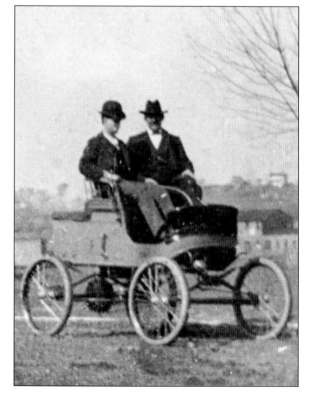

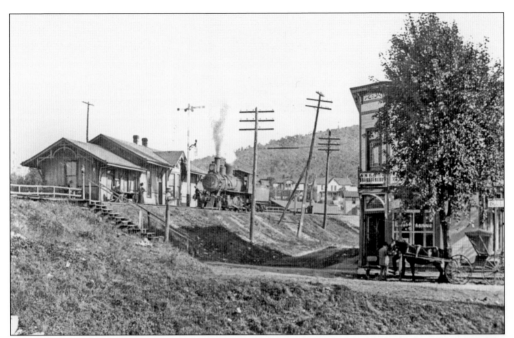

This *c.* 1900 Basic City photograph, taken from the Norfolk and Western train station on Commerce Avenue, shows a steam engine arriving at the Chesapeake and Ohio station, having just traversed over the mountain through the Blue Ridge Tunnel. A horse and carriage are in front of the Blue Ridge Restaurant. (Courtesy Waynesboro Public Library.)

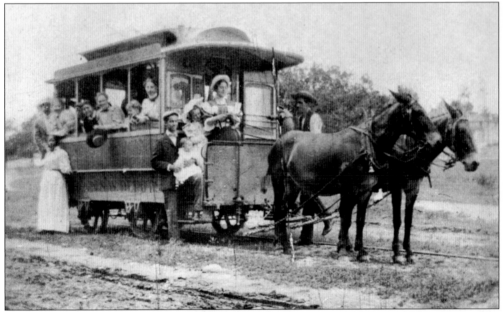

Beginning around 1895, a mule-drawn trolley system connected Basic City to Waynesboro. The tracks ran from the Basic City train station west across the Main Street Bridge to the intersection of Main Street and Wayne Avenue. One set of tracks turned south and continued to the Brunswick Hotel (or Inn). The other track went north to the Waynesboro Chesapeake and Ohio station. Service ceased around 1904. (Courtesy Waynesboro Heritage Foundation.)

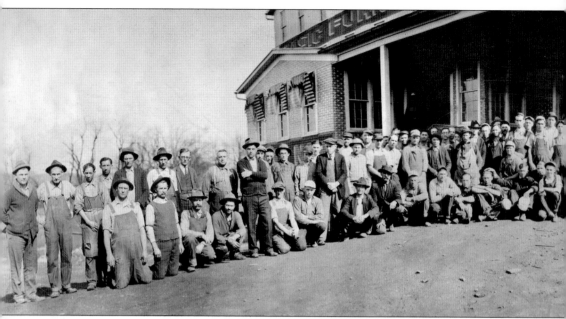

Basic Furniture Company, located between Fourth and Fifth Streets in Basic City, replaced the School Desk and Furniture Company, which survived only four years from 1892 to 1896. Julius Witz of Staunton founded the new company, and he divided his time between running the Basic Furniture Company and the J. L. Witz Furniture Corporation in Staunton. The Basic Furniture

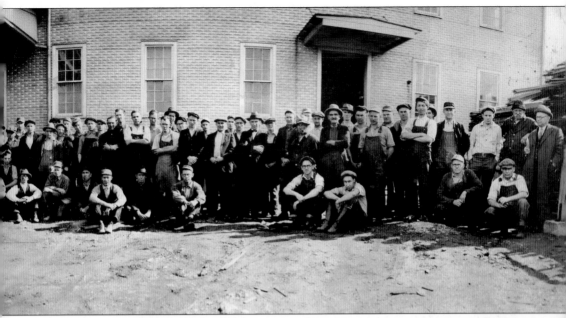

Company was successful into the late 20th century, changing names over the years to Basic-Witz Furniture and then Stanley Furniture. It closed in 1992. This c. 1920 photograph shows the 118 Basic Furniture employees posed in front of the factory building. (Courtesy Waynesboro Public Library.)

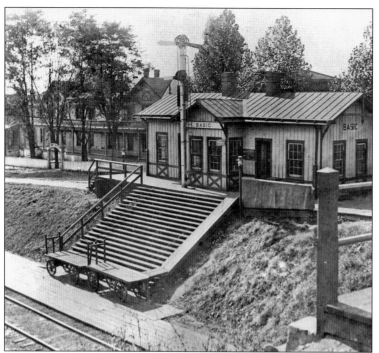

The Norfolk and Western train station was a stone's throw from the Chesapeake and Ohio station, as the Chesapeake and Ohio tracks ran over top of the Norfolk and Western tracks. This *c.* 1910 photograph shows the Norfolk and Western station and the Belmont Hotel, which primarily served customers in transit. The station is gone, but the Belmont still stands as an apartment building. (Courtesy Waynesboro Heritage Foundation.)

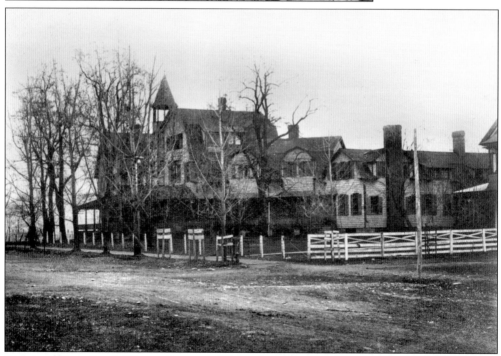

Built in 1891 on South Wayne Avenue in Waynesboro, the Hotel Brunswick stood where Grace Lutheran Church is now located. The hotel offered dances and socials during the boom days of the 1890s into the 1930s. It was first owned by the Loth family and later by the Dorrier family. The Basic City Trolley offered transportation to the hotel for visitors who arrived by train in Basic City. The hotel closed in 1937. (Courtesy Waynesboro Heritage Foundation.)

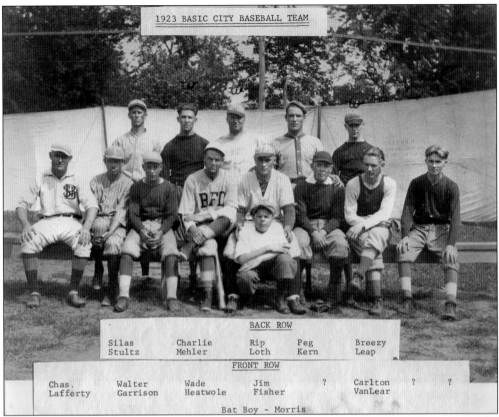

1923 BASIC CITY BASEBALL TEAM

BACK ROW				
Silas Stultz	Charlie Mehler	Rip Loth	Peg Kern	Breezy Leap

FRONT ROW							
Chas. Lafferty	Walter Garrison	Wade Heatwole	Jim Fisher	?	Carlton VanLear	?	?

Bat Boy - Morris

Team sports were reasons to get together, compete, cheer, and celebrate. The popularity of local baseball teams, such as the one sponsored by Basic City, escalated in the 1920s. (Courtesy Waynesboro Heritage Foundation.)

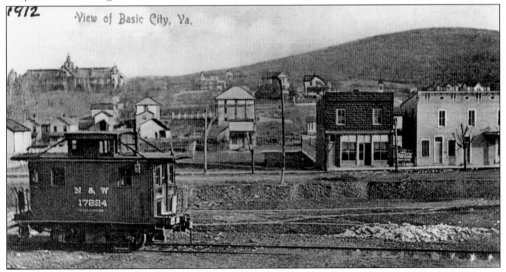

This 1912 photograph, looking east, shows the Basic City rail yard with a Norfolk and Western caboose in the foreground and stores along Commerce Avenue in the background. The Hotel Brandon can be seen on the hill in the upper left. (Courtesy Waynesboro Public Library.)

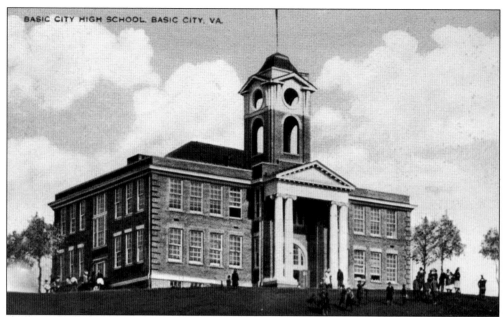

Basic City High School, built in 1912, had a price tag of $40,000. R. J. Costen was the first principal of the school. Located atop Wenonah Hill on North Bayard Avenue, the high school later became Wenonah Elementary School. This postcard, published by H. L. Cooke, of Waynesboro-Basic, Virginia, was mailed in 1917, six years prior to the consolidation of the two towns. (Courtesy Waynesboro Heritage Foundation.)

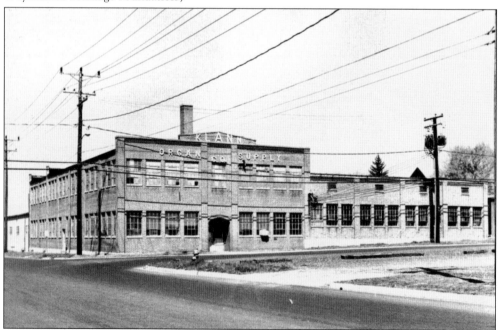

The Klann Organ Supply Company, founded by August Klann in Ohio in 1910, moved to Basic City in 1918 so the business would be closer to the Barckhoff Organ Company, a major customer. The factory continues to produce high-quality organ parts such as consoles, manual keyboards, pedal keyboards, drawknobs, and more. (Courtesy Waynesboro Public Library.)

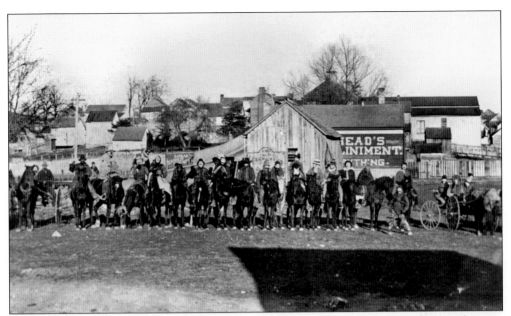

Basic City moved past the rough years of the mid-1890s and into the new century, with many loyal citizens remaining in town and beginning new businesses to replace the old. Basic City residents, like people everywhere, enjoyed festivities. This 1899 photograph shows Basic City men and women on horseback wearing costumes and masks. It is believed they were preparing for a parade. (Courtesy Waynesboro Public Library.)

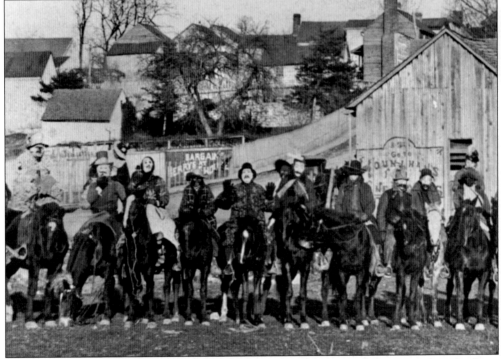

This detail of the photograph above shows the men and women and their varied masks, hats, and outfits. (Courtesy Waynesboro Public Library.)

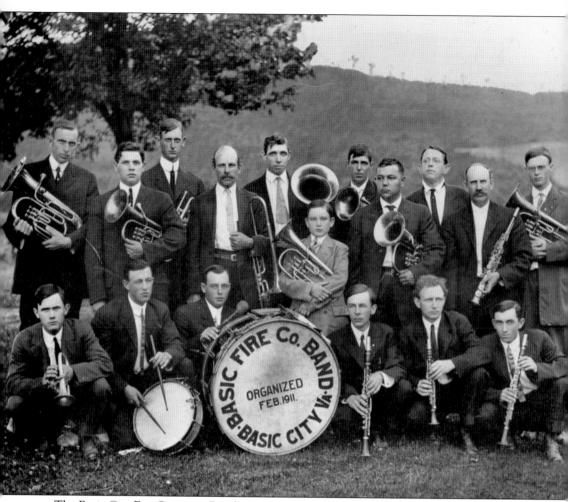

The Basic City Fire Company Band was organized in February 1911. This photograph was taken two years later near Lithia Springs, with members posing with euphoniums, clarinets, a bass drum, a snare drum, and other instruments. The band, directed by J. B. McGahey of the J. B. McGahey Machine Works, played at various civic functions throughout its history. The band took part in the parade celebrating Woodrow Wilson's homecoming in Staunton in 1912. It was still performing as a group in 1928 when Pres. Calvin Coolidge arrived by train on November 28th on his way to a Thanksgiving getaway at Swannanoa and Charlottesville. When the president and his wife disembarked, the couple were hurriedly presented flowers by Fairfax Hall girls and Boy Scouts, given military greetings by Fishburne cadets, and listened to a march played by the Fire Company Band before they were whisked away up the mountain. (Courtesy Waynesboro Heritage Foundation.)

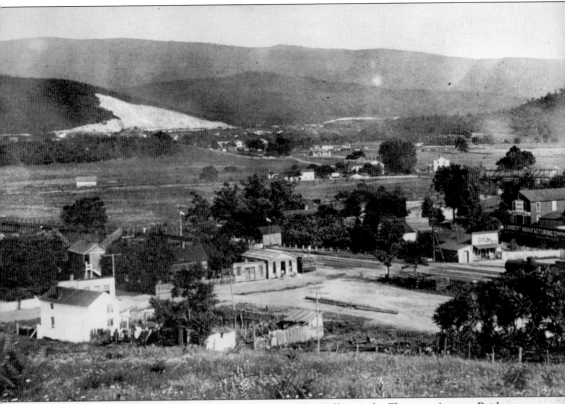

This *c.* 1900 photograph was taken from the Port Republic Hill near the Florence Avenue Bridge, overlooking the Chesapeake and Ohio railroad track that ran west out of Basic City and across the South River into Waynesboro. The Lambert Manufacturing Company, which made furniture and sold lumber, can be seen at the right in the background, situated between Ohio Street and Mulberry Street (now Broad Street). The Chesapeake and Ohio trains usually stopped at both the Basic City and Waynesboro stations, even though they were only a mile apart. As were most other stations, the one in Waynesboro was segregated "white" and "colored." However, the Ellis family, African Americans who operated a restaurant in the city, was allowed to sell sandwiches, cake, and fried chicken to the passengers in both sections. (Courtesy Waynesboro Public Library.)

To Voters of Basic City

Ex-Mayor Griffith's Reply To Mayor Maxwell

We are very sorry that Mayor Maxwell waited until the last issue of the town's paper before he published his article. The very reason that Mayor Maxwell gives for consolidation I have against consolidation. It had been reported that he would publish an article favoring consolidation. I had not believed he would because he told me that "Basic" was losing nearly three thousand a year in pumping water to Waynesboro at the present rate. And that if he had the selling of "Basic" spring he would not take one hundred thousand dollars for it. Now giving half of the spring and electric plant to Waynesboro; for what? What prevents factories from coming to Basic—we have factories now—the consolidation further inducements. Why has Prof. Hudgins built a new school in Waynesboro? Why has Prof. Maxwell bought and improved his school in Basic? Did consolidation induce either? No.

Nothing could have induced Prof. Maxwell to have opened a "Girls' School" in Basic City twenty-five or thirty years ago. Why? Ask the citizens that were here and Waynesboro then. If we (and I and am one of the few old citizens of thirty years ago) stood the heat and battle of the financial depression and other disadvantages and were able to keep on our feet, now is it right for the younger people who have come in since and give way (even half interest) in our spring and plant that cost us over fifty thousand dollars [50,000.°°]. If one half is done, that is reported that consolidation people will do we poor old Basic mortals will have nothing to do but to fold our arms and prepare to "sail through bloody seas on flowery beds of ease."

We know why certain agents advocate consolidation—that which makes the mare go—money! Others who said that Basic City was too long for our P. O. name and advocated cutting off the "City" are now preaching for "Waynesboro-Basic". "Consistancy thou art a jewel".

The report printed—which is said to be the report of the two towns—it may be and may not be; for the original report was not signed by a single member of the committee, does not do justice to Basic. We are sorry that our committee did not see that the report was correct. Report did not mention our spring for which we paid over twenty thousand dollars. It also put the R. R. and real estate at $645,490.00 which should have been $908,764.00 a loss of over $283,000.00 beside no deduction from Waynesboro for High School and County building of the one-fourth interest owned by the county, which amount [over sixteen thousand dollars] which will have to be refunded by the "BIG CITY" — W & B. If Waynesboro is in position to not only help Basic but put her on the map "remember please Basic is thirty-five years old and Waynesboro over one hundred and thirty-five. We are sorry that Waynesboro has been so long in getting on the map. Leave Basic alone and before she is half of one hundred and thirty-five years of age she will be on the "BIG MAP".

Certain supposed advantages have been suggested but these are more imaginary than real, or if real or more than offset by decided disadvantages. Are large towns more economically governed than small ones? NO.

We cordially ask all who can to vote with us to save Basic City.

A person can hardly love his country unless he loves that part of it which he calls home.

> "Breathes there a man with soul so dead,
> Who never to himself hath said;
> This is my own, my best loved town?"

> "I know her faults, but love her still;
> And in spite of youth and stubborn will,
> To her I will evermore be true."

> "And should she drop beloved name,
> And wed for fortune or for fame;
> For her my heart will still be true."

Vote Against Consolidation

Signed R. S. GRIFFITH, M. D.

The issue of merging Basic City and Waynesboro into one city was a hot topic in the early 1920s. Many saw the benefits of combining services. Not all agreed. This open letter to the voters of Basic City was written by R. S. Griffith, former mayor of Basic City. He declared, "Are large towns more economically governed than small ones? NO." Griffith appealed to voters' sense of small-town loyalty and financial independence. However, he did not get his wish. Consolidation occurred in 1923. (Courtesy Waynesboro Heritage Museum.)

Three

THE MOUNTAIN-VALLEY CONNECTION

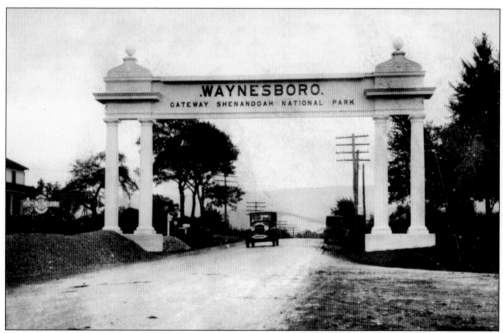

In 1926, Congress resolved to create the Shenandoah National Park in the Blue Ridge Mountains. The park and the Blue Ridge Parkway, which travels the length of the mountains to the Smokies, were built by the Civilian Conservation Corps in the 1930s. Waynesboro was given the title "Gateway to the Shenandoah National Park." The West Arch commemorated this honor. It sat where Main Street and Rosser Avenue now intersect. (Courtesy Waynesboro Heritage Museum.)

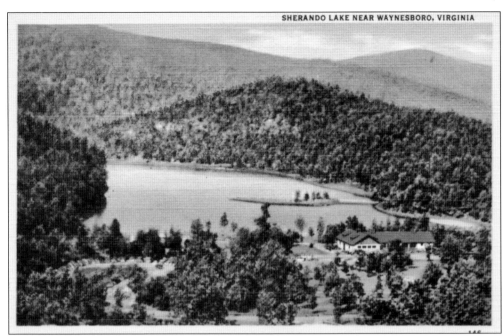

Surrounded by the Blue Ridge Mountains, Sherando Lake sits just south of Waynesboro. This recreational area, called the "Jewel of the Blue Ridge Mountains" by local citizens, was established by the U.S. Forest Service in the George Washington National Forest and was built by the Civilian Conservation Corps (CCC) in the 1930s. Sherando Lake remains a popular vacation spot for campers, anglers, hikers, and swimmers. (Courtesy Waynesboro Public Library.)

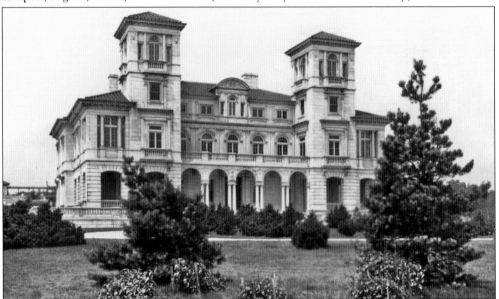

Built by James H. Dooley on 1,000 acres of land he purchased from J. B. Yount, the Swannanoa "palace" took eight years to complete and was finished in 1912. This 52-room marble mansion is located on the crest of the Blue Ridge Mountains just east of Waynesboro. In 1949, Walter and Lao Russell leased the estate and established the University of Science and Philosophy. The palace now stands empty. (Photograph by R. L. Hiserman; courtesy Waynesboro Public Library.)

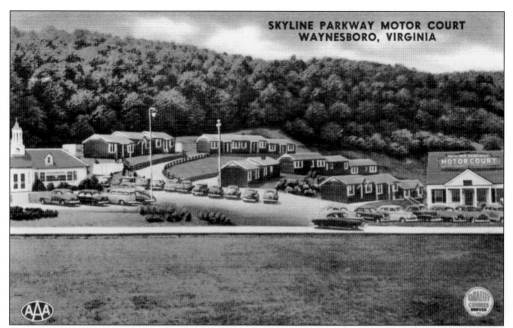

With the development of the Shenandoah National Park, Blue Ridge Parkway, and Skyline Drive, more tourists visited Waynesboro and the surrounding area. This postcard shows the Skyline Parkway Motor Court and Howard Johnson's restaurant, which sat atop the Blue Ridge Mountains at Rockfish Gap on Route 250 just east of Waynesboro. Built in 1949, the motel offered scenic views of the valleys to the east and west. (Courtesy Waynesboro Public Library.)

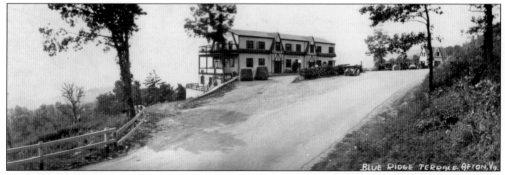

The Blue Ridge Terrace Inn was located on the eastern side of Rockfish Gap, a mile from the Skyline Drive. It entertained guests through the early 1900s, and now the building is used as apartments. This photograph was taken before Route 250 was straightened out in the late 1930s. (Courtesy Waynesboro Public Library.)

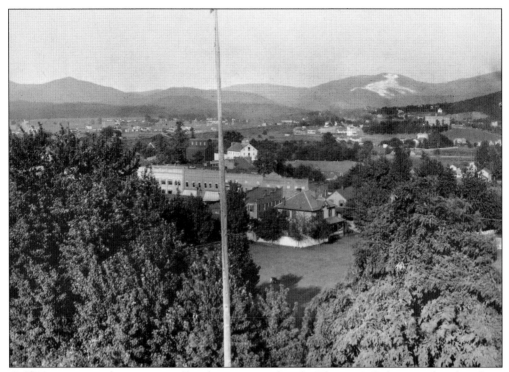

Calf Mountain was long a point of local curiosity and pride. This *c.* 1915 photograph, taken from the top of Fishburne Military School, shows the calf-shaped clearing on the ridge. The calf's front hoof points to the dome on Basic City High School. Some say the clearing was natural. Others claim the trees were cut down that way on purpose and for fun, beginning in the 1870s. Today much of the clearing has grown over. (Courtesy Waynesboro Public Library.)

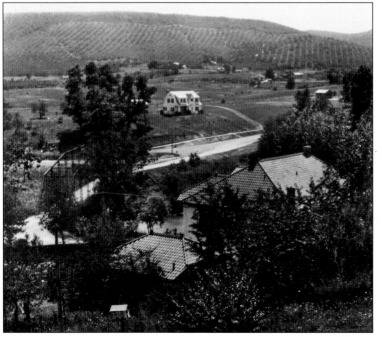

Apples were a large part of Waynesboro's economy during the late 1800s and into the mid-1900s. This 1932 photograph shows the Chestnut Avenue Bridge looking southeast toward the Blue Ridge Mountains and apple trees that line the ridge. These trees were part of the Jordan Orchard. The white house stands where the Kenmore subdivision is now located. (Courtesy Waynesboro Public Library.)

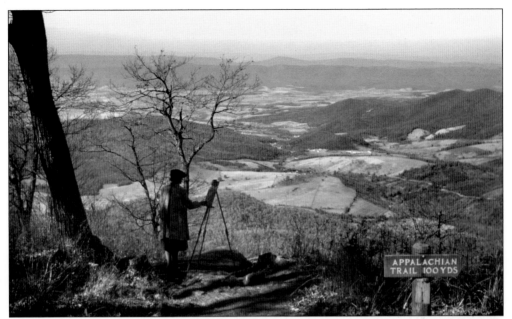

Completed in 1937, the Appalachian Trail extends from Georgia to Maine, covering more than 2,170 miles. A portion of this scenic trail winds through the Blue Ridge Mountains, passing just east of Waynesboro. For years, Waynesboro has served as a mail drop for Appalachian Trail hikers, who come down into town to pick up packages and mail letters and sometimes camp on the grounds of the YMCA. (Library of Congress, Prints and Photographs Division, FSA-OWI Collection.)

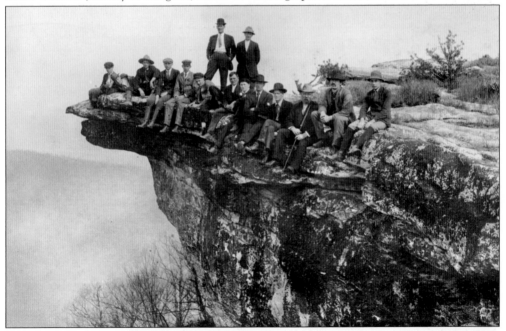

Humpback Rock, located off the Blue Ridge Parkway several miles south of Rockfish Gap near Waynesboro, has long been a popular hiking destination. This photograph, taken during the first quarter of the 20th century, shows a group of men who have hiked to the rock to take in the view. (Courtesy Waynesboro Public Library.)

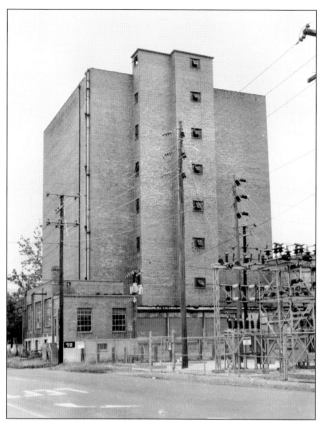

Local orchards such as the Rose Cliff Orchards and Harnsbarger Orchard produced thousands of bushels of apples in the early autumn months. These apples needed to be stored prior to being processed and canned or shipped beyond Waynesboro. Casco Cold Storage Plant, built in 1930 on Arch Avenue, offered year-round storage service. It was capable of holding 55,000 bushels. The building, now vacant, still stands. (Courtesy Waynesboro Public Library.)

The Mountain Top Inn or Hotel, located at Rockfish Gap just east of Waynesboro, was built as a tavern in 1777. In an 1842 notice in the Staunton *Spectator*, it was touted for its "pleasant air, its scenery, and its waters." The inn was destroyed by fire in 1909. (Courtesy Waynesboro Public Library.)

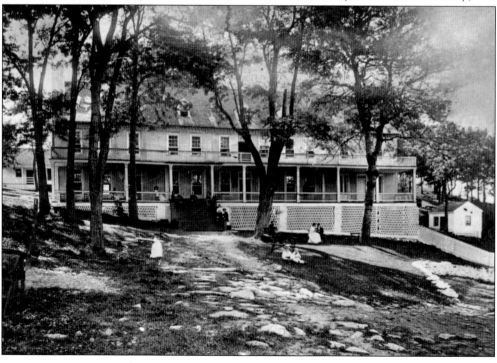

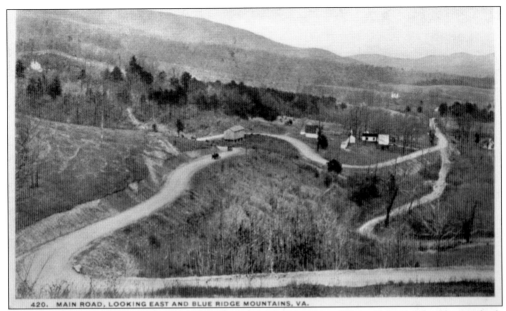

420. MAIN ROAD, LOOKING EAST AND BLUE RIDGE MOUNTAINS, VA.

Crossing the Blue Ridge Mountains from the Piedmont region to Waynesboro in the Shenandoah Valley proved challenging for early motorists. This early-20th-century postcard from the Hiserman Studios shows some of the difficult turns faced by those in automobiles who decided the trip was worth the time and effort. (Photograph by R. L. Hiserman; courtesy Ron Hiserman.)

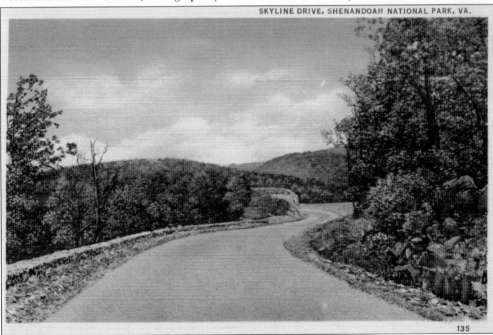

SKYLINE DRIVE, SHENANDOAH NATIONAL PARK, VA.

Dedicated in 1936, the 30,000-acre Shenandoah National Park was created to help preserve the natural beauty of the Blue Ridge Mountains as well as to make jobs for the CCC members who built it. This postcard shows Skyline Drive, the portion of the Blue Ridge Parkway that travels through the Shenandoah National Park and offers views of the valleys to both the east and west. (Courtesy Waynesboro Public Library.)

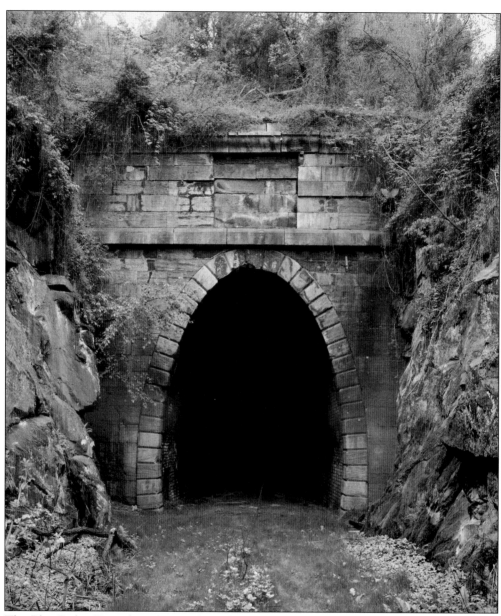

The Blue Ridge Tunnel, or Crozet Tunnel, helped bring the railroad across the Blue Ridge Mountains at Rockfish Gap to Waynesboro. Begun in 1854 under the engineering supervision of Claudius Crozet, the tunnel was ready for scheduled train service in 1858. The structure was an amazing feat—the longest tunnel in the United States, drilled from both sides to a precise meeting point. During the Civil War, the Confederate army moved troops and supplies through the tunnel. It remained part of the regular train route until 1945, when a new, adjacent tunnel was built. (Courtesy Library of Congress, Prints and Photographs Division, Historic American Engineering Record.)

Four

Roads, Rails, Rivers, and Wings

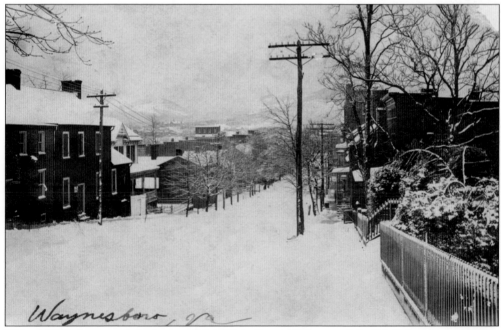

This *c.* 1900 photograph looks east down Main Street Hill toward the Main Street and Wayne Avenue intersection. The fence on the right bordered Waynesboro Presbyterian Church, which was vacated in 1912, later becoming the Star Theater and then the *Waynesboro News-Virginian.* Main Street Hill has long been a city landmark, offering a scenic view as well as causing difficulty for drivers in ice and snow. (Photograph by R. L. Hiserman; courtesy Ron Hiserman.)

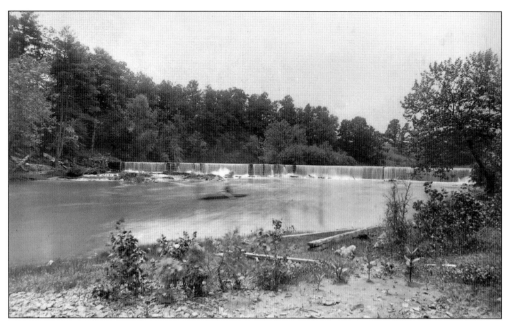

This undated photograph shows a lone boater paddling the waters of the South River. In the 19th century and into the early 20th century, South River had a series of dams at intervals along its length. The river provided a source of power to industries and farmers. The dammed water also created a place for swimming, fishing, and boating. (Photograph by R. L. Hiserman; courtesy Waynesboro Heritage Foundation.)

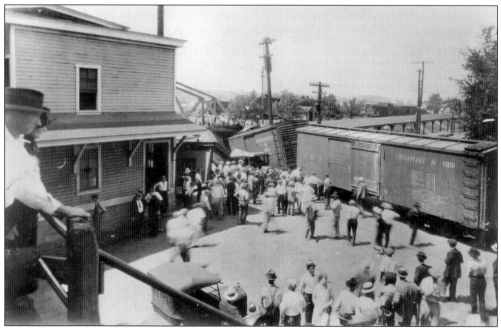

On June 22, 1925, a runaway boxcar traveling on the Norfolk and Western train track demolished the passenger station and killed one woman. The break wheel had locked. This photograph was taken from the nearby Chesapeake and Ohio station. Note the iron bridge-like turntable in the background. (Courtesy Waynesboro Public Library.)

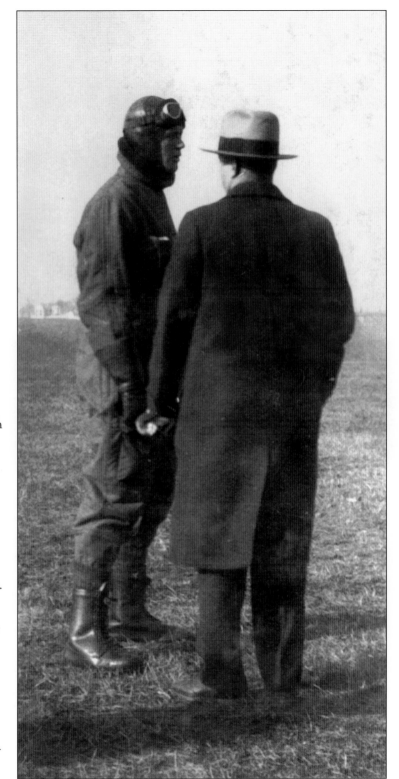

Carl C. "Rip" Loth (right) chats with famed aviator Charles A. Lindbergh in October 1927, the month in which Loth established Waynesboro's Valley Airport. Rip Loth, son of W. J. Loth, who founded the Loth Stove Company, was a World War I pilot and flight enthusiast. Lindbergh was making a three-month goodwill tour of the United States in his transatlantic Ryan monoplane, the *Spirit of St. Louis*. During this tour, he visited the Shenandoah Valley. (Photograph by R. L. Hiserman; courtesy Ron Hiserman.)

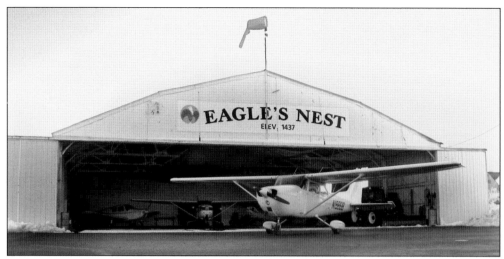

Eagle's Nest Airport opened in 1954 when Waynesboro's Valley Airport was closed. It is located at the west end of town at a latitude of 38° 04' and a longitude of 78° 56'. The airport remains in service, offering a paved taxiway for small airplanes and flight instruction for interested customers. Glider enthusiasts use Eagle's Nest Airport as a base for soaring. (Photograph by Cortney Skinner.)

In the 1960s, Waynesboro Girl Scouts occasionally took train rides to Charlottesville on Amtrak. Because of the easy access to cars and airplanes by that decade, train travel in the area was beginning to decline, so this was an adventure for girls who had never had a chance to ride the rails. In this June 1964 photograph, Brownie Troop 453, including Cathy VanPatten (standing, far left), waits for their train at the Waynesboro station. (Courtesy Catherine VanPatten.)

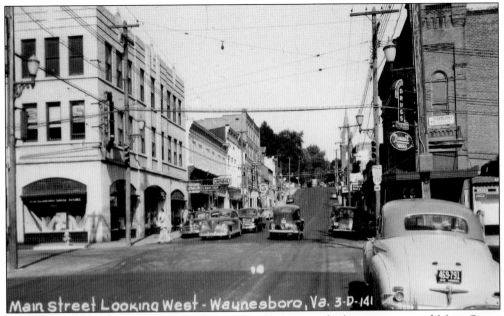

Main Street Looking West - Waynesboro, Va. 3-D-141

Waynesboro had a bustling downtown in 1950. The view is looking west toward Main Street Hill, showing the two competing drugstores at the intersection of Main Street and Wayne Avenue—Drake's Waynesboro Drug Store on the left corner and Fishburne Drug Store on the right. The steeple of Main Street Methodist Church is visible at the top of the hill on the right. (Courtesy Waynesboro Heritage Foundation.)

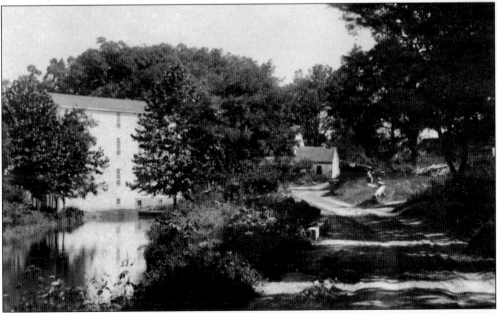

Gardner's Mill, known as Patterson's Mill until the late 1800s, was located by the South River between Broad and Main Streets where the Pavilion at Constitution Park now stands. The mill, a major Waynesboro industry, produced flour. It was destroyed by fire on March 21, 1953. This undated photograph was inscribed on the back, "Gardner's Mill, Waynesboro. Gift of Nancy Etter." (Courtesy Waynesboro Heritage Foundation.)

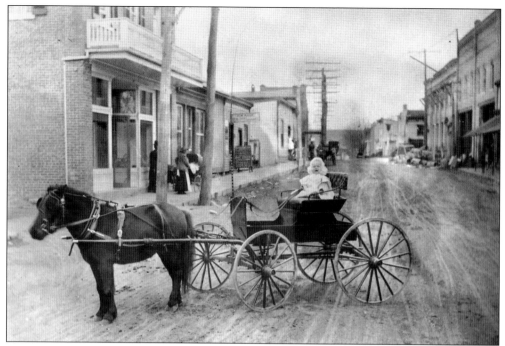

This 1901 photograph shows an unidentified child in a buggy, posed on an unpaved Wayne Avenue about a block from the Main-Wayne intersection, looking north. (Photograph by R. L. Hiserman; courtesy Waynesboro Public Library.)

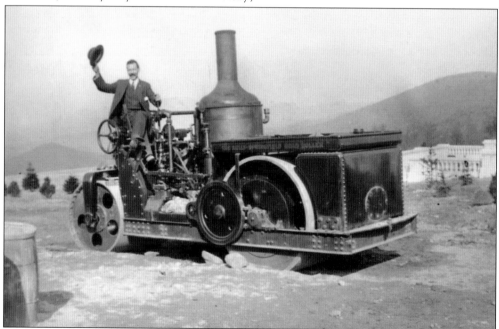

This dapper, cheerful gentleman at the controls of a steam-powered Kelly-Springfield Road Roller is Ree Ellis of Basic City. He and Virgil Moyer of Waynesboro were hired by James H. Dooley to build the Swannanoa mansion and prepare the roads around the grounds. The construction was completed in 1912. (Courtesy Waynesboro Heritage Foundation.)

J. L. Fisher and Son Bus Line offered service from Waynesboro to Staunton in the west and to Charlottesville in the east. Owners J. L. Fisher and Norman L. Fisher claimed they had held a perfect service record since 1917 until the blizzard of 1932 stopped them cold in their tracks because of unplowed roads. This late-1920s photograph shows the "Miss Waynesboro" bus on Eleventh Street beside Fishburne Military School. (Photograph by R. L. Hiserman; courtesy Ron Hiserman.)

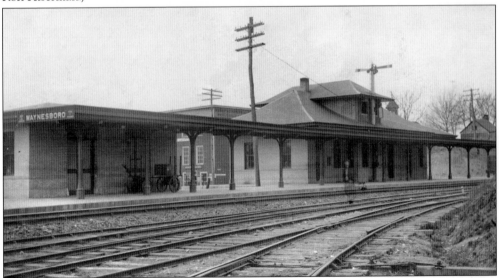

This Hiserman Studios postcard, postmarked 1912, shows Waynesboro's Chesapeake and Ohio station along Ohio Street. The steeple over the right side of the station roof is the old First Methodist Church, built in 1833, which later became Main Street Methodist Church. (Photograph by R. L. Hiserman; courtesy Ron Hiserman.)

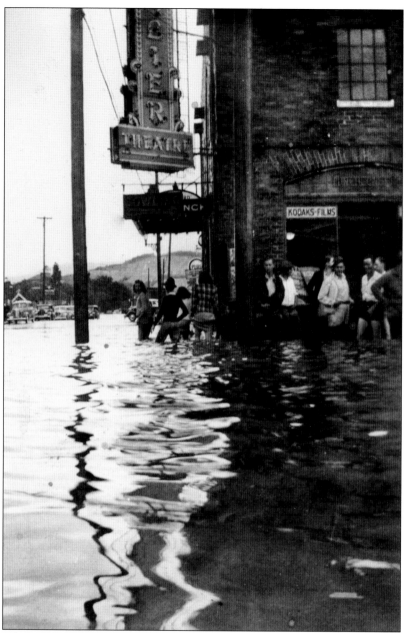

Ever since the city was founded, the South River has been notorious for flooding Waynesboro's low-lying areas. One major flood occurred on March 17 and 18, 1936. This flood caused the city's electricity and telephone service to fail. It forced the closure of the Norfolk and Western train line, holding trains up in Hagerstown, Maryland, and Roanoke, Virginia. Many riverside plants, including DuPont, shut down and waited for the muddy waters to recede. Town manager I. G. Vass had his hands full, directing volunteers and city employees to help rescue citizens and pets that had become stranded in homes and businesses. Several houses were ruined beyond repair, and many others sustained serious damage. This photograph shows people braving the floodwaters outside the Cavalier Theater and bowling alley at the corner of Main Street and Arch Avenue, holding up skirts and enduring soaked trousers. (Courtesy Waynesboro Public Library.)

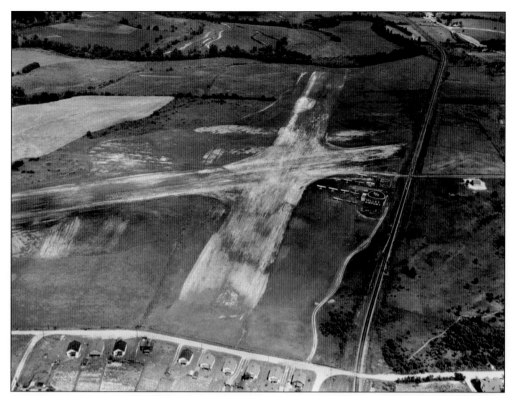

A bird's-eye view shows the Valley Airport, built by Carl C. "Rip" Loth in 1927. This small airport with its unpaved strips served the community until 1954, when it was moved to its current location and renamed Eagle's Nest Airport. Painted on top of the hanger is an arrow pointing north, showing a latitude of 38° 06' and a longitude of 78° 52'. (Courtesy Waynesboro Heritage Foundation.)

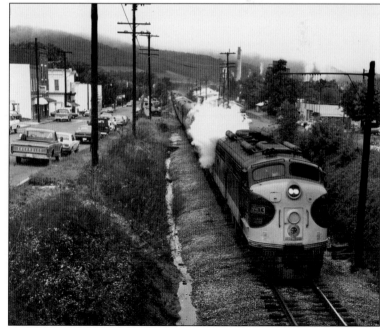

A train travels north on the Norfolk and Western tracks along Commerce Avenue in this 1970 photograph. DuPont smokestacks can be seen in the distance to the right. Although travelers are no longer able to catch a train in Waynesboro, freight train service remains a constant. (Courtesy Waynesboro Public Library.)

R. L. Hiserman, a photographer, had his first studio in a house at the corner of Federal Street and South Wayne Avenue where the present-day post office is located. The studio and darkroom were downstairs. The Hiserman family lived upstairs. This postcard, dated 1910, shows the Hiserman Studio sign on the left and the white fencing along the Fishburne Military School field on the right. (Photograph by R. L. Hiserman; courtesy Ron Hiserman.)

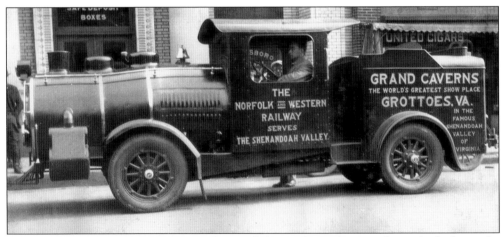

The Norfolk and Western "train car" advertised the north-south route along which the tracks traveled, offering service to the scenic Grand Caverns north of Waynesboro in Grottoes. This 1920s-period photograph was taken on Main Street, with the train car parked in front of the Citizens-Waynesboro Bank on the left and Fishburne Drug Store on the right. (Photograph by R. L. Hiserman; courtesy Ron Hiserman.)

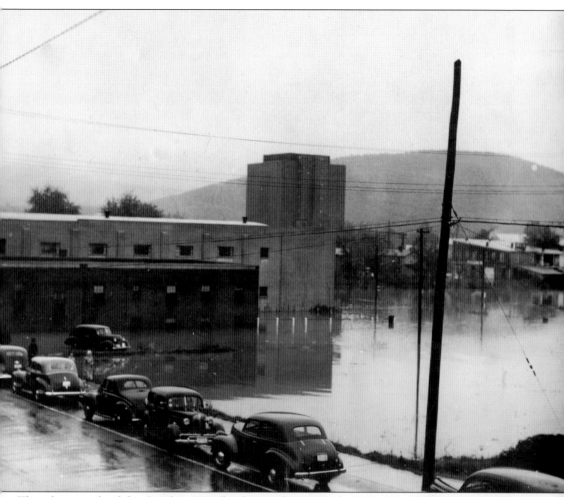

This photograph of the October 1942 flood was taken on Federal Avenue looking east toward Arch Avenue and the Casco cold storage at the corner of Arch and Short Street. The building in the foreground is the bowling alley, which had moved from the basement of the Cavalier Theater—due to frequent flooding. Severe, continuous rainfall that lasted from October 12th until the 15th sent the South River up and over its banks to flood much of the lower portions of the city, as well as a large portion of the Shenandoah Valley. Rising water and landslides along the ridges east of the city caused the Chesapeake and Ohio railroad line to close. While other businesses and factories shut down during the flood, Wayne Manufacturing continued its work on behalf of the war effort. (Courtesy Waynesboro Public Library.)

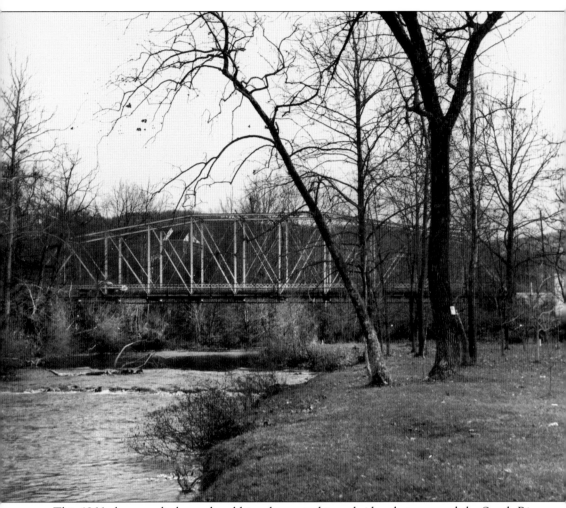

This 1966 photograph shows the old two-lane, steel-truss bridge that spanned the South River immediately north of where Meadowbrook Road and Lyndhurst Road meet. Due to the fact that this bridge was located in an area where there were many apple orchards, it was often called the "Apple Acres" bridge. It was also called the "second bridge," the "first bridge" being the identical one that crossed the South River at Chestnut Avenue closer to the center of town. Under the leadership of city manager Charles T. Yancey in 1963, the *c.* 1890 Chestnut Avenue bridge was torn down and replaced. The "Apple Acres" bridge was replaced four years later. (Courtesy Waynesboro Public Library.)

Five

RUNNING THE CITY

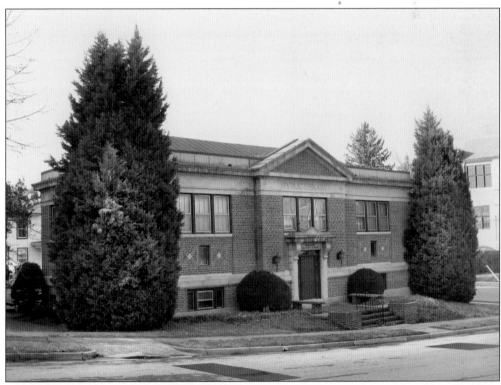

A Carnegie Foundation grant allowed Waynesboro to construct its first public library building, which was completed in 1915. Designed by T. J. Collins, the building still stands at 313 Walnut Avenue. One unique feature is a frieze beneath the eaves on which names of famous literary figures are inscribed. This library served the public until 1969, when the new library opened on Wayne Avenue. The building now belongs to Fishburne Military School. (Photograph by Cortney Skinner.)

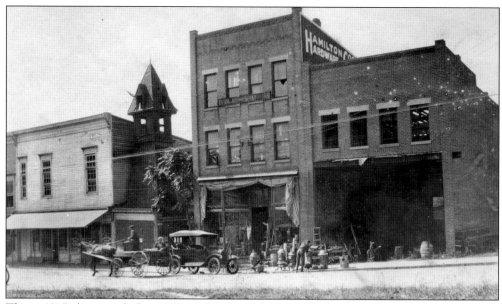

This *c.* 1915 photograph shows Waynesboro's old firehouse and its siren tower, located on North Wayne Avenue to the left of the Hamilton Cook Hardware Store. The fire department was established in May 1893, and Fred Jesser was the department's first fire chief. (Courtesy Waynesboro Public Library.)

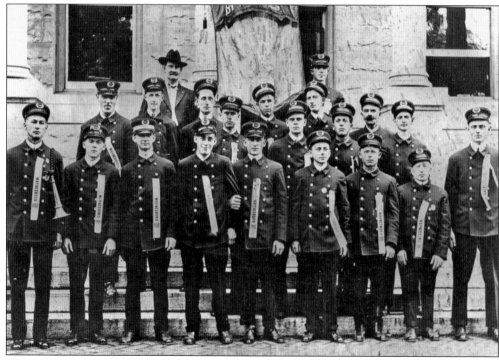

This group portrait, taken in 1916, shows the members of the Waynesboro Fire Department standing in an undisclosed location, sporting ribbons presented to them "By the Ladies." In that same year, the fire department purchased its first fire vehicle, a Ford Model T truck. (Courtesy Waynesboro Public Library.)

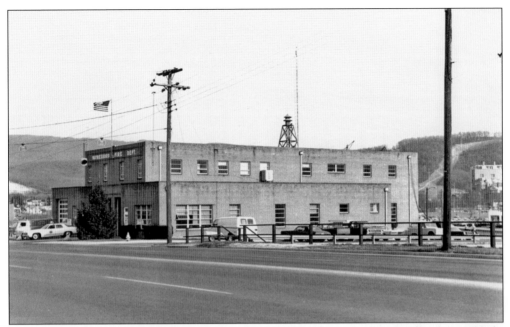

Waynesboro's new fire station, shown in this 1978 photograph, was built in 1954 at the southwest corner of Arch Avenue and Broad Street for a cost of $60,000. The Waynesboro Fire Department is still located in this building, offering firefighting and emergency medical services to the city. (Courtesy Waynesboro Public Library.)

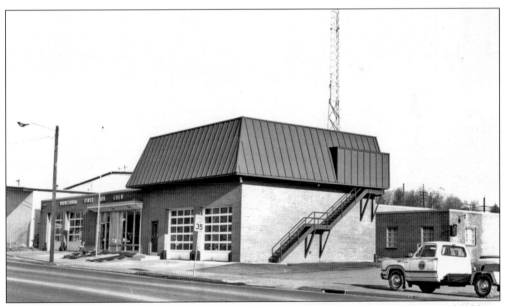

The Waynesboro Volunteer First Aid Crew was founded in 1951. The present crew building, shown here in 1978, was constructed in 1966 at the northeast corner of Broad Street and Arch Avenue. In 1975, the rescue crew was named the No. 1 Rescue Squad in Virginia by the Virginia Association of Volunteer Rescue Squads. In 1979, five members of the squad became the first in the Shenandoah Valley to be certified as EMT shock technicians. (Courtesy Waynesboro Public Library.)

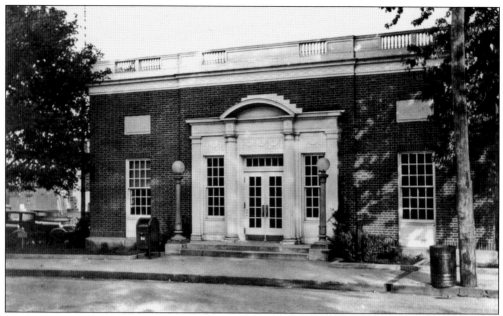

In 1918, Waynesboro contracted for a new post office to be built at the corner of Federal Street and South Wayne Avenue. The R. L. Hiserman home and photography studio was torn down for this purpose, and Hiserman moved his business to the upstairs of the Gaw Office Building across the street. This early-1930s photograph shows the front of the post office. (Courtesy Waynesboro Public Library.)

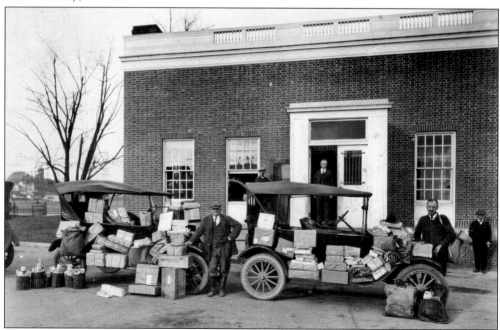

This photograph shows the rear of the post office at the corner of Federal Street and South Wayne Avenue around 1925. From left to right are Charles Brunk (carrier), Harry Redd (janitor), J. H. Furr (postmaster), Emmett East (carrier), and Lynn Carter, known as the "town character." (Courtesy Waynesboro Public Library.)

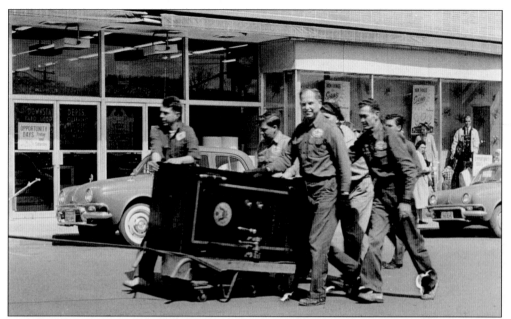

In 1959, a new post office replaced the one built in 1918. It was located at the same spot—the corner of Federal Street and South Wayne Avenue. This 1960 photograph shows men rolling a new vault up Federal Street past the rear entrance to J. J. Newberry's Department Store for placement in the post office as curious shoppers look on. (Courtesy Waynesboro Heritage Museum.)

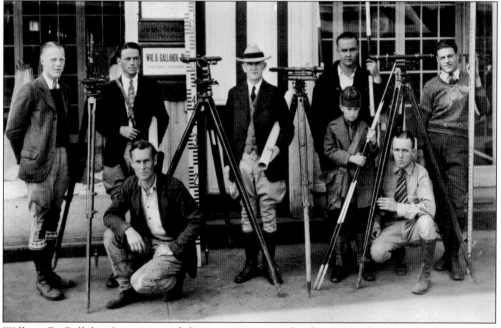

William B. Gallaher Jr. pauses with his surveying team for this 1920s photograph taken in front of his office. Gallaher's team surveyed for numerous city infrastructure and utility projects. Posing here from left to right are George Baylor, Amos Sweet, ? Nolen, W. B. Gallaher Jr., Doves ?, Bill Gallaher, Roy Sullender, and Lyle Hiserman, son of photographer R. L. Hiserman. (Photograph by R. L. Hiserman; courtesy Ron Hiserman.)

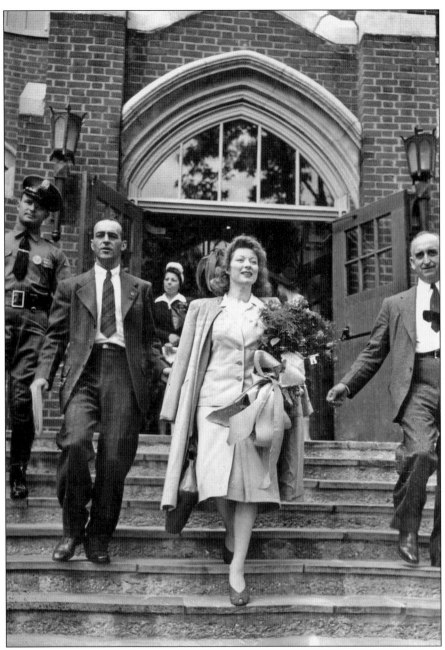

In 1942, Waynesboro began a concerted effort to raise money for the war effort through the sales of war or defense bonds. Local schools, radio stations, banks, factories, and stores promoted the sale of the bonds. The Cavalier and Wayne Theaters sold bonds and stamps in their lobbies. Waynesboro's first war bond parade was held on April 13, 1942. Several months later, on September 8th, movie star Greer Garson visited Waynesboro to drum up even more support for the Defense Bond Drive. A gathering was held in the morning on the Fishburne Military School grounds. Later the first 200 people to buy at least a $100 bond were allowed to have lunch with the actress. More than $24,000 was raised by the event. Here Garson comes down the Fishburne school steps. (Photograph by R. L. Hiserman; courtesy Ron Hiserman.)

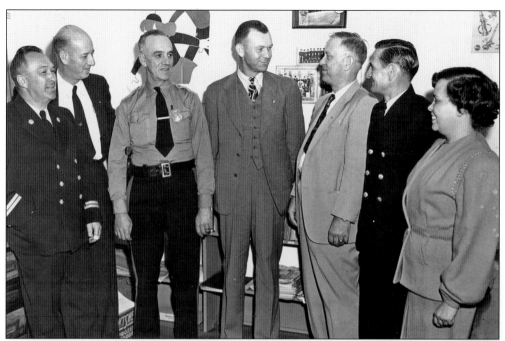

City leaders gather for this *c.* 1949 photograph. From left to right are J. Guy Rusmiselle, Waynesboro safety engineer; Francis Loth, mayor; police chief Wade R. Drumheller; W. T. "Ham" Wells, new city manager; I. G. Vass, outgoing city manager; D. A. Slingo, volunteer fireman; and Edith McCrary Fitzgerald Phillips. (Courtesy Waynesboro Public Library.)

The Yancey family has been in Waynesboro since the late 1800s. Charles T. Yancey served as Waynesboro's city manager from 1957 until his retirement in 1989. Prior to that, he was the city manager in Sylvania, Georgia. The present-day Charles T. Yancey Municipal Building on the corner of Main Street and Wayne Avenue was named for him. (Courtesy Kin and Debbie Yancey.)

In the mid-20th century, Waynesboro's city hall was located at 126 North Wayne Avenue, at the corner of North Wayne and Spring Alley (now Spring Street). The city government offices were moved to a new building at the corner of South Wayne Avenue and Eleventh Street in 1961, where the old Valley Seminary once stood. (Courtesy Waynesboro Public Library.)

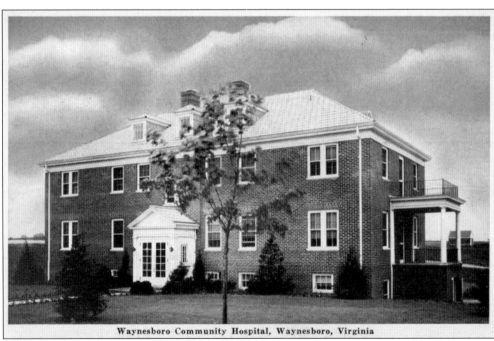

Waynesboro Community Hospital, Waynesboro, Virginia

Waynesboro's first hospital was situated in the former Loth house at 453 South Wayne Avenue in 1934. When city needs outgrew the building's size, a new hospital was planned. This postcard shows the new Waynesboro Community Hospital, built in 1937 at 1701 West Main Street. The hospital staff consisted of 19 doctors, including Drs. B. K. Weems, Lyle S. Booker, D. E. Watkins, and H. B. Webb. This building now houses the McDow Funeral Home. (Courtesy Waynesboro Public Library.)

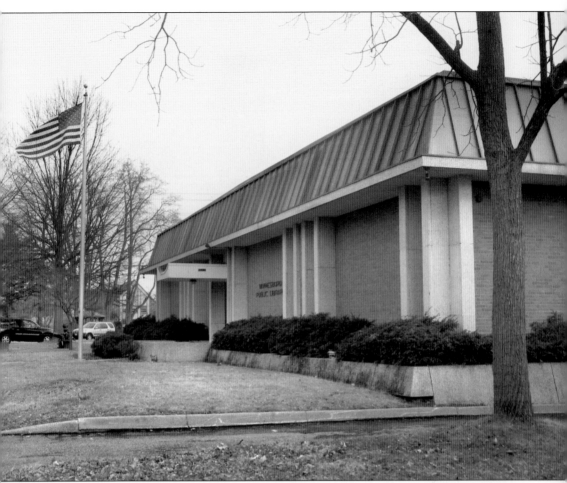

Waynesboro's public library was located in the Carnegie-funded structure on Walnut Avenue from 1915 until 1969, when the city approved the building of a new library. It was constructed at 600 South Wayne Avenue, next to the property of Grace Lutheran Church, where the Brunswick Inn once stood. This new library building served the public well until it outgrew the initial walls, and the building was enlarged in 1979, increasing its size to twice what it was. The library remains in this location, providing books, audio books, adult computer classes and book clubs, story times for children, local history archives, and more to the citizens of Waynesboro. (Photograph by Cortney Skinner.)

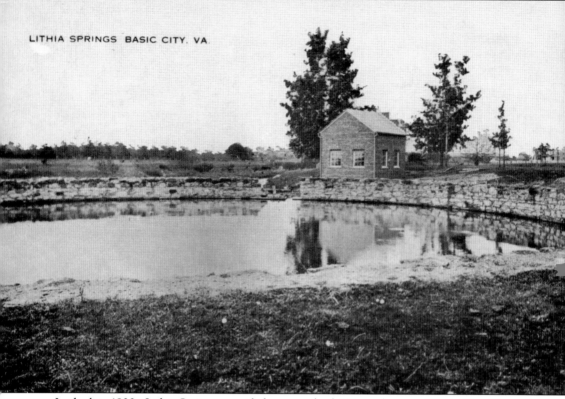
LITHIA SPRINGS BASIC CITY. VA.

In the late 1800s, Lithia Springs provided water to both Waynesboro and Basic City. The spring, located east of the South River, pumped water through pipes across the South River to Waynesboro's Maple Avenue tank and to a reservoir behind the Brandon Hotel in Basic City. The water from Lithia Springs was claimed to be beneficial to health and was advertised as so by local hotels. The spring was surrounded by a rock wall, and the park property itself was enclosed by a wire fence to keep out stray cattle. After Waynesboro and Basic City consolidated, the water source was used for a few more years until DuPont bought the property. At that time, the Coyner Springs property was developed as a city water supply. (Courtesy Waynesboro Public Library.)

Six

RELIGION AND EDUCATION

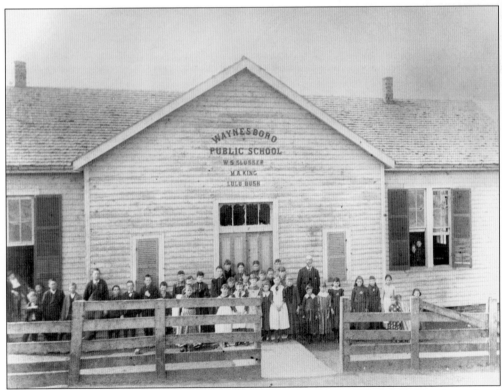

Slusser School offered education to white Waynesboro students in 1890 after the Academy closed down. It was located at the intersection of Ohio Street and New Hope Road. In this *c.* 1890 photograph, W. S. Slusser, principal and teacher, can be seen to the right of the front door. (Courtesy Waynesboro Heritage Foundation.)

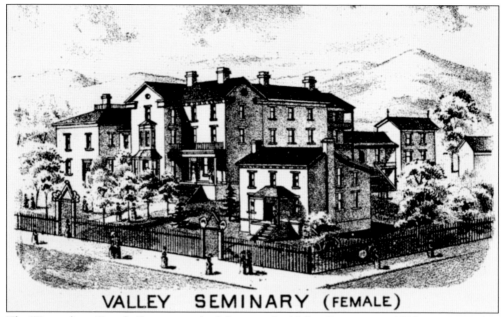

VALLEY SEMINARY (FEMALE)

The Waynesboro Female Seminary, which became the Valley Seminary in 1888, was situated at the corner of South Wayne Avenue and First (now Eleventh) Street. The Valley Seminary offered a structured course of study for young ladies under the initial principalship of Elizabeth Guy Winston. Students took academic classes, attended church, and were sternly reminded that Waynesboro was a dry city and drinking was against the law. (Courtesy Waynesboro Heritage Foundation.)

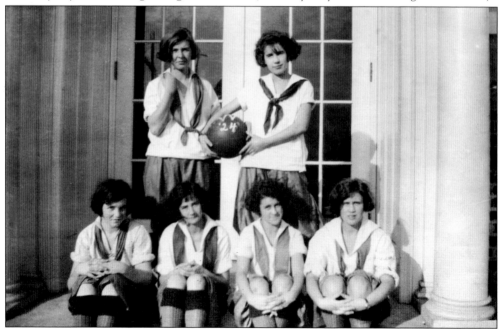

Waynesboro's new Wilson High School, located on Pine Avenue, opened in September 1923. In this photograph, the 1924–1925 girls' basketball team poses in front of the school. They won their very first game on October 24, 1924, against Raphine, 78-1. In 1925 and 1926, they were runners-up in the state girls' basketball finals. (Photograph by R. L. Hiserman; courtesy Ron Hiserman.)

Shiloh Baptist Church began in the 19th century holding worship services in an old blacksmith shop on Ohio Street near the Florence Avenue Bridge. In 1872, members of the Shiloh Baptist Church built a small frame building on the corner of Shiloh Avenue and Minden Place. In 1924, the current church, built of glazed tile and concrete block, was erected at the same location. (Photograph by Cortney Skinner.)

Completed in 1932, St. John's Catholic Church stands at the corner of Eleventh Street and Maple Avenue. It is constructed of Blue Ridge limestone and trimmed with Indiana limestone. The church's first Mass was celebrated on June 4, 1932, by Fr. Emmett Gallagher. The church opened St. John's Catholic School in 1962 in an addition on the east end of the church. The school operated until 1972. (Courtesy Waynesboro Public Library.)

Waynesboro's Rosenwald Colored School was built on Port Republic Road in 1924 as part of a project funded by philanthropist Julius Rosenwald, whose goal was to improve public education for African Americans in the South. It was closed in 1966 following Waynesboro's school desegregation. The building now houses the Waynesboro African American Museum and offices of the Department of Parks and Recreation. (Photograph by Cortney Skinner.)

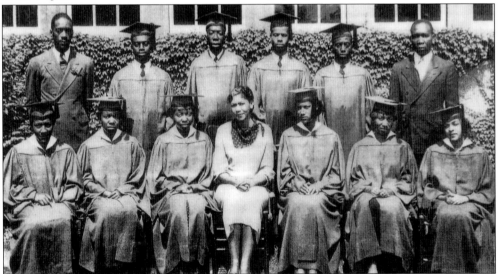

Rosenwald Colored School's first graduating class, the class of 1937, poses in caps and gowns. From left to right are (seated) Lorraine Hobson, Christine Nicolas, Sarah Nicolas, Ruth Bryant (teacher), Harriette Goodall, Geneva Becks, and Lillian Lytle; (standing) Alfred Ham (teacher and basketball coach), William Woodson, John Henry Mosley, Jake Sims, Frank Davis, and Dr. James Nicolas (principal). (Courtesy Waynesboro Heritage Foundation.)

In 1963, the new Kate Collins Junior High School on Ivy Street opened to educate the city's seventh, eighth, and ninth graders. It was during that time that Waynesboro began the process of desegregation, which took place over several years. The Rosenwald Colored School closed its doors for the last time in June 1966. Though the integration went smoothly, students did not always find it a comfortable or easy process. Former FBI agent Eugene Perry Jr., a Rosenwald student who moved to Kate Collins as an eighth grader in 1966, said of the experience, "It was like going to another world. My parents, aunts, and uncles had all attended Rosenwald. I'd dreamed of being Valedictorian of my graduating class from Rosenwald like my mother had been, and of being on Rosenwald's basketball team. But my dreams went up in smoke." (Courtesy Waynesboro Public Library.)

Methodists have been in Waynesboro since 1824. Their first church was a log structure near the present-day Florence Avenue Bridge. A new church building, shown here in a photograph dated around the dawn of the 20th century, was built at the top of Main Street Hill in 1874. A newer, enlarged Main Street Methodist Church was built in 1956 with modern renovations, including an elevator, which was completed in 2008. (Courtesy Waynesboro Public Library.)

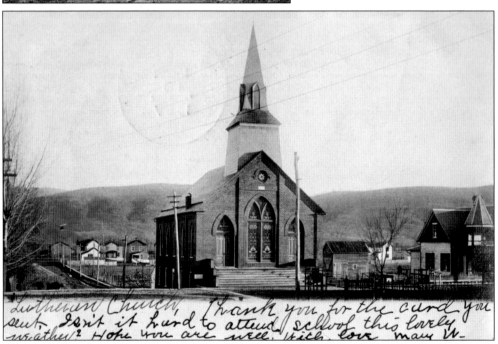

The original Grace Lutheran Church was built in 1894 at the corner of South Wayne Avenue and Eleventh Street and is seen in this 1909 postcard. The church constructed a new building where the Brunswick Hotel had once stood in 1958, and the old church was eventually torn down. (Courtesy Waynesboro Public Library.)

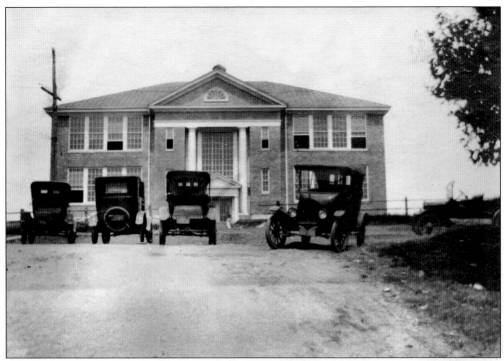

The first of Waynesboro's three Pine Avenue schools was constructed in 1906. It served white students only. The second building, next to the first, was completed in 1912. That school became the high school while the other was used for elementary classes. In 1922, the third building was completed. It became Wilson High School. This c. 1923 photograph, taken from the crest of Eleventh Street, shows the new high school. (Photograph by R. L. Hiserman; courtesy Ron Hiserman.)

This detail of a panoramic photograph shows some students of the Waynesboro city school system, of both of elementary and high school age, in front of the Pine Avenue school buildings on March 26, 1923. (Courtesy George Robertson.)

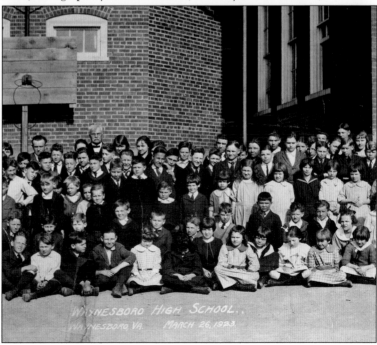

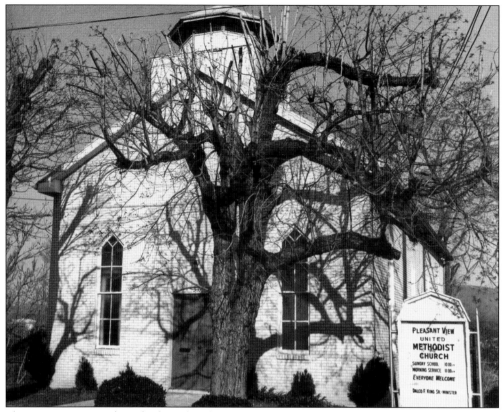

Pleasant View United Methodist Church was organized in 1867 with the first members meeting in a schoolroom. In 1870, the first church building was erected on a plot donated by Joshua Hill, a freed slave, who had been given a large tract of land west of the South River in the Port Republic area. This photograph shows the church in 1959. It burned in 1979, but rebuilding began the following day. (Courtesy Waynesboro Public Library.)

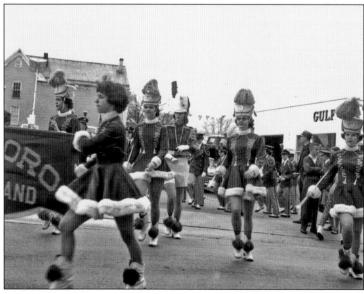

The Waynesboro High School band majorettes parade through town in April 1961. The specific parade is unidentified. (Courtesy Waynesboro Public Library.)

This photograph, taken at the start of the 20th century, shows the Presbyterian church at 544 West Main Street, at the top of Main Street Hill. The building of the church took place from 1874 until 1878 and was completed at a cost of $7,208. In 1912, the congregation moved to its present location at the corner of North Wayne Avenue and Eleventh Street. (Courtesy Waynesboro Public Library.)

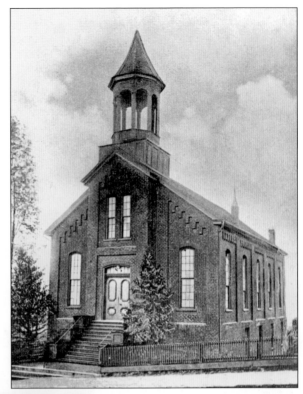

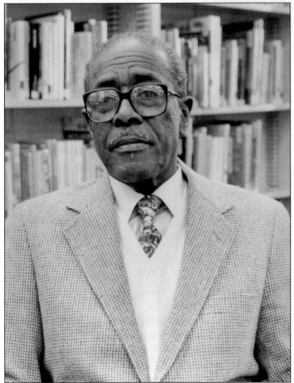

Waynesboro native William W. Perry was educated at the Rosenwald school. After earning his bachelor's and master's degrees, he taught at Rosenwald for five years before moving to work elsewhere. He returned to Waynesboro in 1957 to serve as Rosenwald's principal. Perry was instrumental in getting the once-unaccredited Rosenwald school accredited and has been cited as the main reason the integration of city schools went as well as they did. (Courtesy Waynesboro Heritage Museum.)

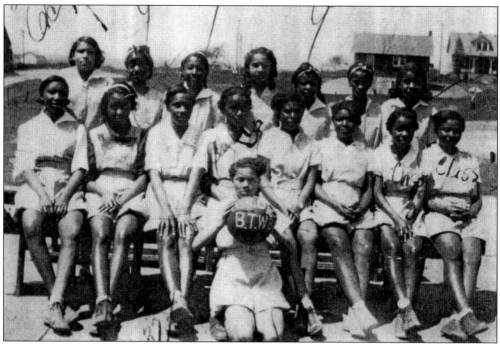

Members of Rosenwald's girls' basketball team pose for the camera in 1934. Although Rosenwald only educated students through grade seven for its first 10 years of operation, a two-room addition was made to the building in 1934, and two years of high school work were added. (Courtesy Waynesboro African American Museum.)

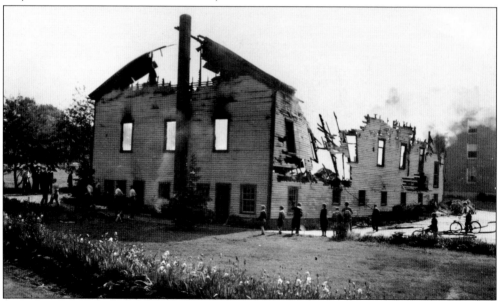

In 1939, a fire destroyed Fishburne Military School's frame gymnasium. This photograph shows the devastation in progress. The T. J. Collins firm was hired to design a new structure that would hold the administration offices, the library, and a fully equipped gymnasium in the rear. The building was completed in 1940 and was dedicated by Judge C. G. Quesenbery at the graduation ceremony that May. (Courtesy Waynesboro Public Library.)

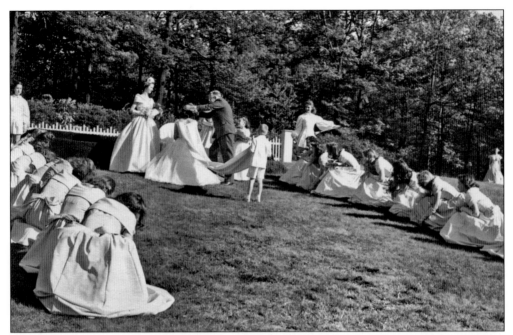

The Brandon Hotel, built in Basic City in 1890, became the coeducational Brandon Institute in 1913. The school was purchased in 1920 by John Nobel Maxwell and converted into Fairfax Hall, a preparatory school for young ladies. This 1948 photograph shows the girls of the Fairfax Hall May Court. The school remained open until 1975, when it closed as a result of increased operating costs and decreased student enrollment. (Courtesy Patrica B. Spilman.)

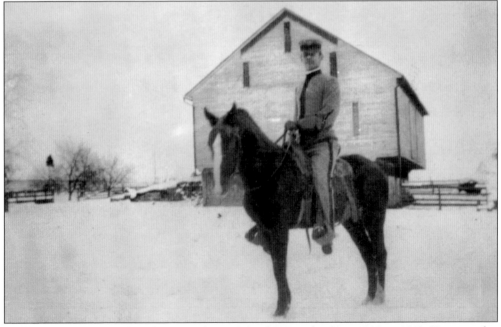

Jack V. Palmer attended Fishburne Military School as a cadet from 1908 to 1912. He was a day student who lived on a farm outside the city. He rode to and from classes each day on his western mustang, Baby. (Courtesy Waynesboro Heritage Museum.)

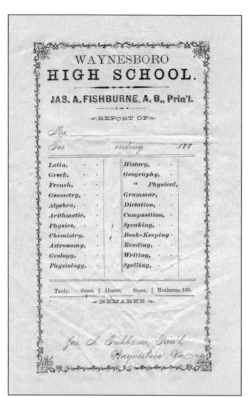

James A. Fishburne, who taught at Waynesboro's Academy for several years, opened his own school in 1879. Known initially as Waynesboro High School, it was coeducational for several years. By 1882, however, the school had become the all-boys Fishburne Military School. This report card, printed with "188_" in the upper right-hand corner, was ready but never marked during the school's three-year lifespan. (Courtesy Waynesboro Heritage Foundation.)

Pres. Calvin Coolidge made a brief appearance in Waynesboro on November 28, 1928, when he arrived by train at the Chesapeake and Ohio station on Commerce Avenue. He and Grace Coolidge were on their way to visit Swannanoa Country Club atop the Blue Ridge Mountains as part of a Thanksgiving vacation. In this photograph, young ladies from the nearby Fairfax Hall present flowers to the First Lady. (Courtesy Waynesboro Public Library.)

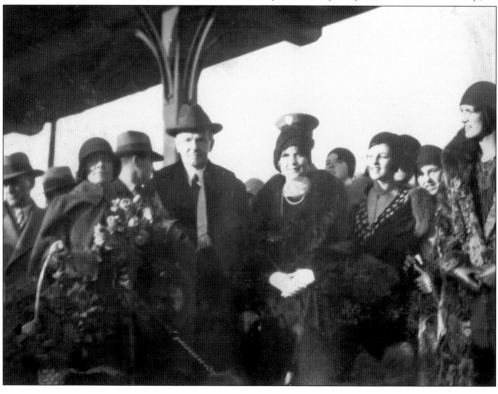

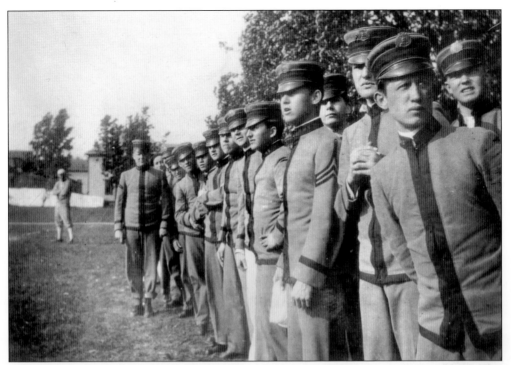

An assembly of Fishburne cadets gathers on the military school field between 1908 and 1912. This photograph is credited to Jack V. Palmer, who rode his horse to school each morning. (Photograph by Jack V. Palmer, courtesy Waynesboro Heritage Foundation.)

By 1930, Waynesboro's Wilson High School was overcrowded. In 1936, the city applied for a Public Works Administration grant for a new Waynesboro High School. Work on the new school began in 1936 and was completed by April 1938. At that time, there were 370 students and 13 faculty members. (Courtesy Waynesboro Public Library.)

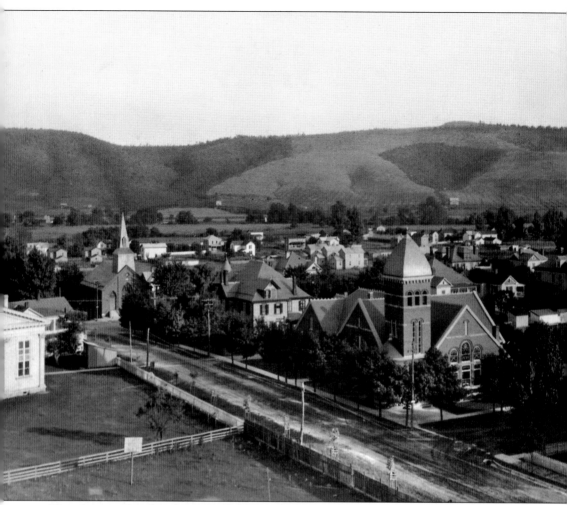

This photograph, taken from atop Fishburne Military School, shows three Waynesboro churches in the 1930s. The light-colored building at the left edge of the photograph facing Eleventh Street is the First Presbyterian Church. Its sanctuary burned in 1984 and was rebuilt in 1986. Catty-corner across South Wayne Avenue is the Grace Lutheran Church. Across the street from the Presbyterian church at the corner of Eleventh Street and Chestnut Avenue (on the right of the photograph) is the First Baptist Church. The Grace Lutheran Church moved several blocks south in 1958. First Baptist relocated to the corner of Eleventh Street and Wayne Avenue in 1963. Both the old Lutheran and Baptist church buildings shown here have been demolished. The Springdale retirement community now stands where Grace Lutheran once stood, and the spot where the old Baptist church was located is now a church parking lot. (Courtesy Waynesboro Public Library.)

Seven

GETTING DOWN TO BUSINESS

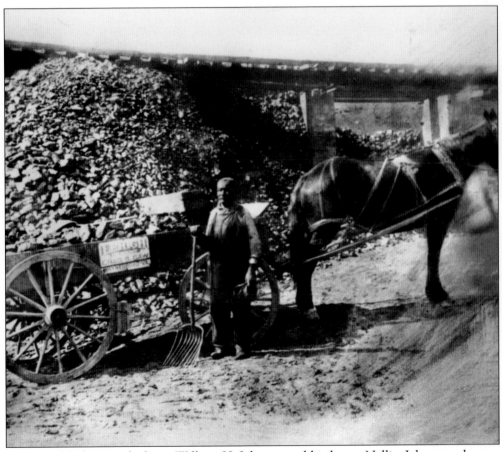

This *c.* 1925 photograph shows William H. Johnson and his horse, Nellie. Johnson, who was born in 1847 and died in 1941, worked for the Charles S. Gaw Hay, Grain, and Feed Company and at the coal yard on Ohio Street across from the Waynesboro Chesapeake and Ohio station. He earned $3 a week. (Courtesy Waynesboro Heritage Foundation.)

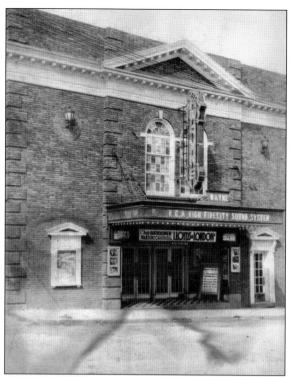

Opening its doors in 1926 and closing in 1999, the Wayne Theater, located at the bottom of Main Street Hill, offered films for the Waynesboro movie-going crowd. The theater initially showed silent films, then was converted to present sound films in 1929. The Wayne replaced the Star Theater, which was across the street at the top of the hill. The movie playing here, *Lloyds of London*, opened in 1936. (Courtesy Waynesboro Public Library.)

Moses Alexander and his family settled in Waynesboro in the early 1800s. In 1836, Moses built a furniture and casket factory on West Main Street just west of present-day Main Street United Methodist Church. William Alexander bought the factory from his uncle in 1844. The business expanded to include the Alexander Funeral Home (now the Hillcrest Building) and a furniture store. This 1926 photograph shows the Alexander Furniture Store. (Courtesy Waynesboro Public Library.)

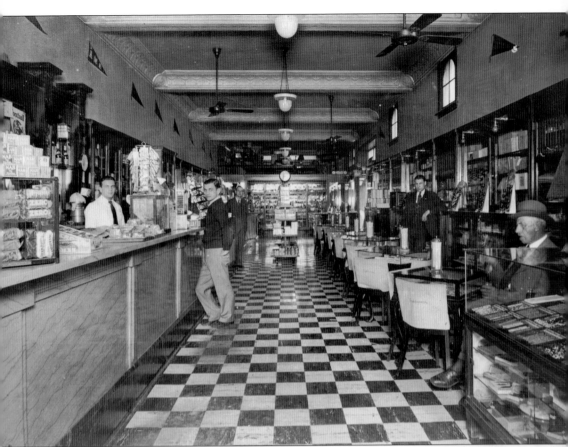

Established in 1878, Fishburne Drug Store was a Waynesboro trendsetter. It was the first business to supply gas for Waynesboro's earliest cars from a store-side pump. In the late 1800s, a soda fountain and magazine rack were installed. Next came a jukebox. This 1930s photograph shows rubber floor tiling installed in 1923. Besides selling pharmaceuticals, the drugstore offered many other up-to-date goods. Visible in this photograph are Peppermint Patties, Snickers, Milky Way, and Zero candy bars. Visitors to the store could also stock up on Nabisco Fig Newtons, individually wrapped chocolate pies, Parker Pens, Skrip ink, pipes, tobacco, and combs. Fishburne customers enjoyed lunching at glass-topped display tables on chairs that sported cloth covers embroidered "Fishburne." (Courtesy Waynesboro Heritage Foundation.)

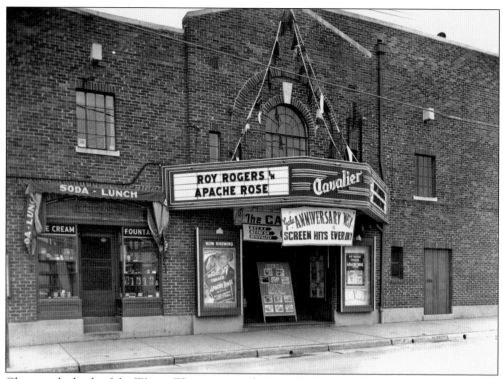

Close on the heels of the Wayne Theater came the Cavalier Theater, built at the corner of Arch Avenue and Main Street. It was designed to show talking pictures and could seat 900 people. The Cavalier also boasted a first-floor luncheonette and a bowling alley in the basement. The movie showing, *Apache Rose*, opened in 1947. The theater closed in 1976. (Courtesy Waynesboro Heritage Foundation.)

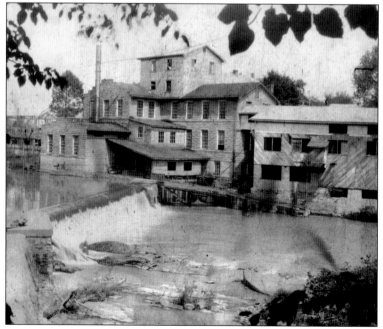

Though it burned twice—once in 1898 and again in 1907—the Rife Ram and Pump Works, situated near the Chestnut Avenue Bridge, continued to produce hydraulic rams and pumps into the first quarter of the 20th century. This early-1920s photograph shows the enlarged factory alongside the dam on the South River, which still exists. (Courtesy Waynesboro Public Library.)

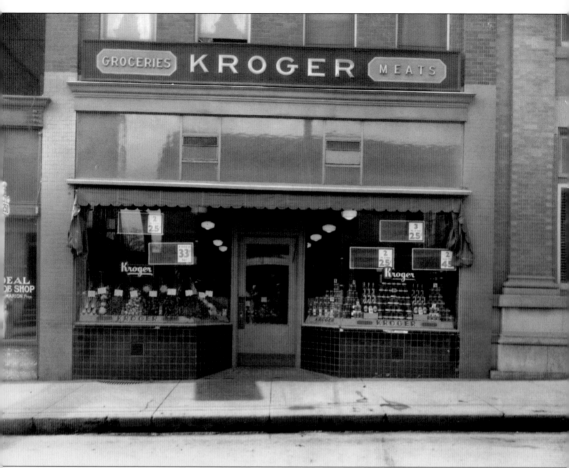

This 1930s photograph shows the Kroger grocery storefront at 322 West Main Street. One of several downtown grocery stores, Kroger offered canned goods as well as fresh meats, milk, vegetables, and kitchen items. In the window on the right, three cans of green beans are offered for 25¢, two cans of peas for 25¢, and two cans of pears for 45¢. Next door to Kroger stood the Ideal Shoe Shop. In 1955, Kroger moved to a new location between Arch Avenue and Market Street, across the street from the Casco Cold Storage building. This much larger store featured an automatic door, conveyor belts at the checkout counters, and neon lights. (Courtesy Waynesboro Heritage Foundation.)

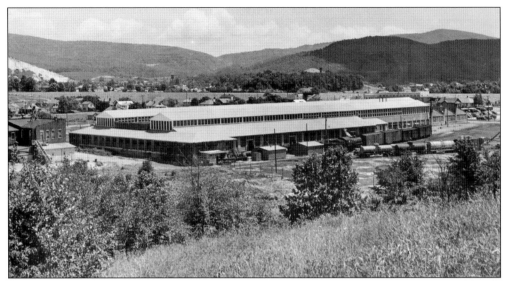

Virginia Metalcrafters took over the vacated East Main Street factory building of the Stehli Silk Mill, which produced silk starting 1925 and closed in 1941. The new company was a descendant of the Rife-Loth Corporation, producing reproductions of early American brass castings until it closed in 2007. This 1940s photograph shows the rear of the factory. The raised rail bed of the Chesapeake and Ohio track can be seen in the distance. (Courtesy Waynesboro Public Library.)

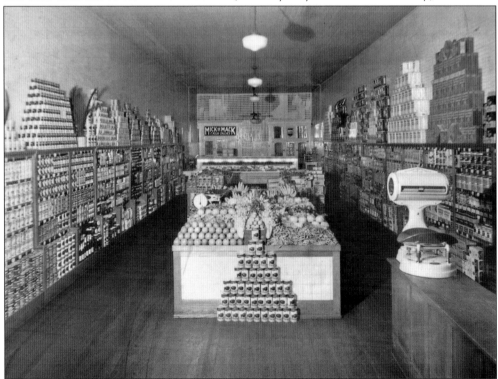

This 1930s photograph shows the tidy interior of the Mick or Mack grocery store, situated at 512 West Main Street. It appears the proprietors did not care to offer credit, as a sign on the back wall reads, "Mick or Mack, Cash Talks!" (Courtesy Waynesboro Public Library.)

The *Valley-Virginian* was founded in 1896 and published local news until 1929. At that time, it was purchased by Louis Spilman and became the *Waynesboro News-Virginian*. This 1920s photograph shows the front of the offices at 122 South Wayne Avenue near the Main-Wayne intersection. (Courtesy Waynesboro Public Library.)

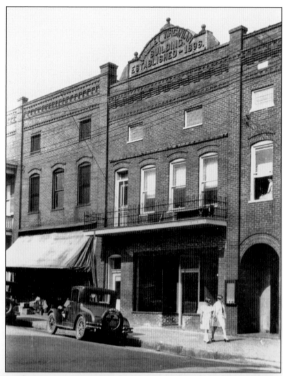

Pliny Fishburne, son of Elliott Fishburne, joined his father in the pharmacy business and assumed full ownership when Elliott died in 1906. Pliny seemed determined to promote innovations that would benefit Waynesboro. It was on the second floor of Fishburne Drug Store that Waynesboro's first telephone exchange was established. This 1915 photograph shows Mac Hupman, manager, standing with chief operator, Myrtle Rusmiselle, and two unidentified seated operators. (Courtesy Waynesboro Heritage Foundation.)

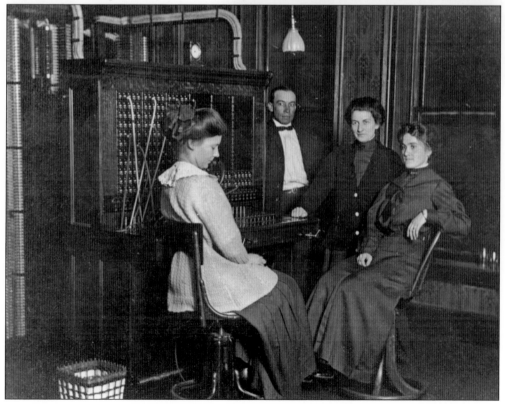

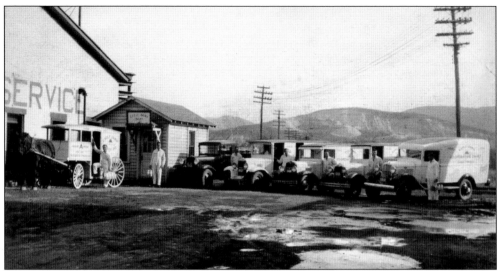

Early Dawn Dairy opened in 1930 on Short Street. In 1938, the milk processing plant moved to East Main Street and added an additional feature, the Early Dawn Dairy Bar, a restaurant. Early Dawn Dairy went out of business in the late 1960s. This 1935 photograph shows the milk trucks ready to roll, as well as one horse-drawn milk wagon. (Photograph by R. L. Hiserman; courtesy Ron Hiserman.)

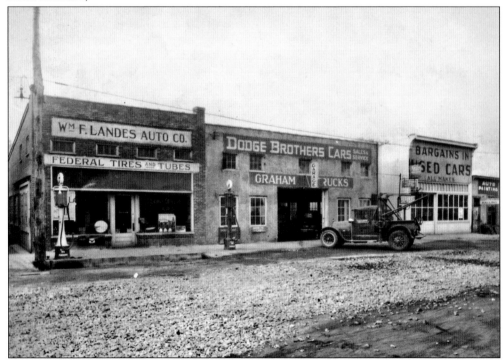

This early-1920s photograph shows the William F. Landes Auto Company, which sold and serviced Dodge Brothers cars and Graham trucks. The company was situated on the south side of Ohio Street, facing the Chesapeake and Ohio train tracks. A manually operated wrecker sits out front. Wrecks were common on weekends, especially on Route 250 coming over the mountain and west along Brand's Flats. (Courtesy Waynesboro Public Library.)

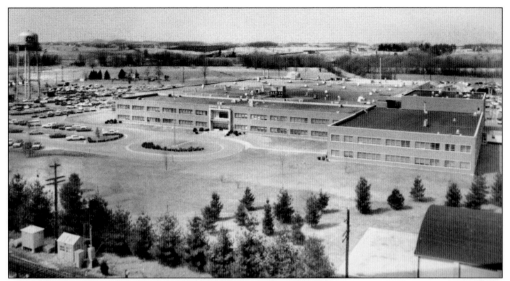

General Electric purchased the property that was the location of the old Valley Airport in 1953 and opened for business in 1954. The Waynesboro plant operated for the next 30 years, producing appliances and other products. In 1983, General Electric sold the property to the Genicom Corporation. In this *c.* 1970 photograph, the Chesapeake and Ohio train track can be seen in the foreground. (Courtesy Waynesboro Heritage Foundation.)

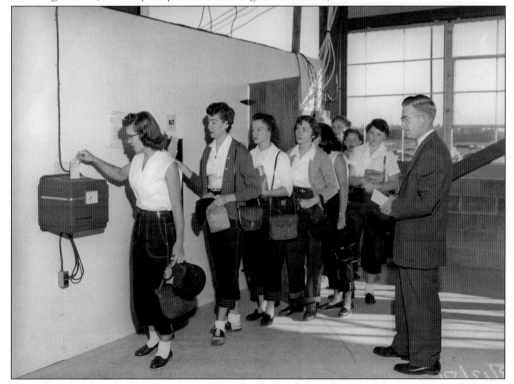

This photograph, taken on September 13, 1954, shows the employees of the new General Electric plant arriving for work on opening day. They are greeted by F. E. Reasoner from the Employee Relations Department. (Courtesy Waynesboro Heritage Foundation.)

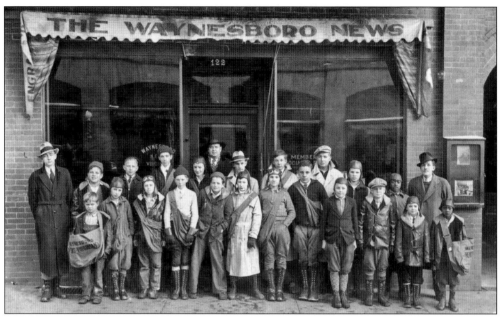

Louis Spilman, founder and publisher of the *Waynesboro News-Virginian*, poses in this *c.* 1935 photograph with the newspaper carriers and several of the newspaper staff. Louis Spilman is in the center of doorway, with staff member Matthews Griffith at far left and J. W. Gentry, company treasurer, at far right. Louis's son, William ("Billy") stands in the first row, second child from the right. (Courtesy Waynesboro Public Library.)

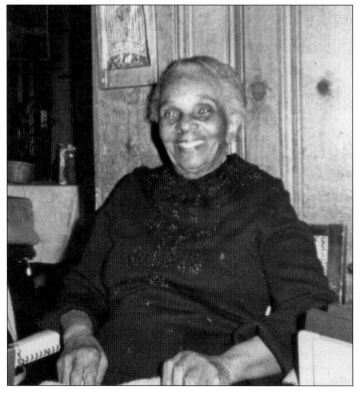

Beatrice Howard Sullivan, or "Mama B," served the Port Republic area as a midwife from 1949 until her retirement in 1976. She did not drive, so she often walked to the homes of the mothers-to-be, even in the worst weather. She delivered 397 babies during her career. Mama B also raised six of her own children, as well as five other children who needed her. This 1969 photograph shows Mama B at home. (Courtesy Nita Bellamy, granddaughter of Beatrice Sullivan.)

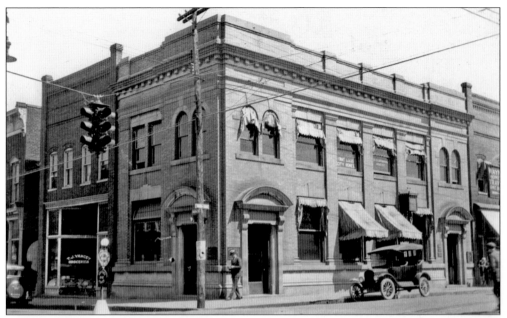

After an 1899 fire destroyed its building on South Wayne Avenue, the First National Bank relocated to the corner of Main Street and South Wayne Avenue. This early-1930s photograph shows the bank with T. J. Yancey Groceries to the left. The Dr. Carl C. Bowman dentist office can be seen on the second floor above the car. The Waynesboro Heritage Museum now occupies this building. (Courtesy Waynesboro Heritage Museum.)

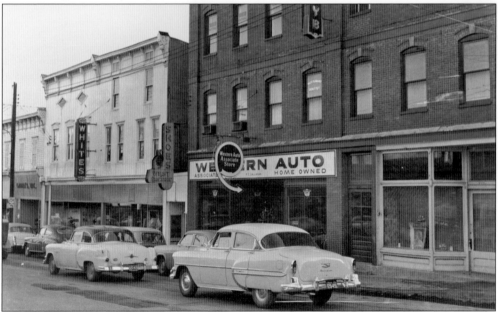

This 1954 photograph of the south side of West Main Street shows some businesses that flourished in the middle of the 20th century, such as Whites Department Store, the West Shoe Store, Western Auto, and the Louise Beauty Salon. On the second floor of the Western Auto building was the office of Dr. F. R. Flanary, a dentist, and on the third floor was the office of the AM radio station, WAYB. (Courtesy Waynesboro Public Library.)

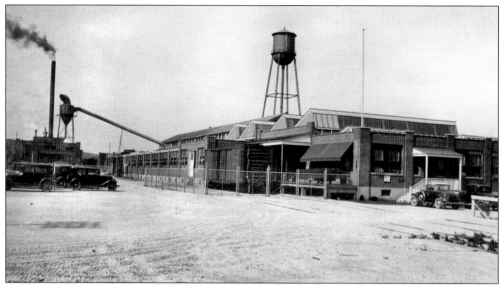

Organized in 1922, the Waynesboro Lumber and Manufacturing Company became one of Waynesboro's main industries and helped make the city a leading industrial center in the Shenandoah Valley. The company was established in Basic City a year before Waynesboro and Basic consolidated. The Waynesboro Lumber and Manufacturing Company produced cruise ship fittings and sold lumber, even throughout the Depression. The name was changed to Wayne Manufacturing in 1937. (Photograph by R. L. Hiserman; courtesy Ron Hiserman.)

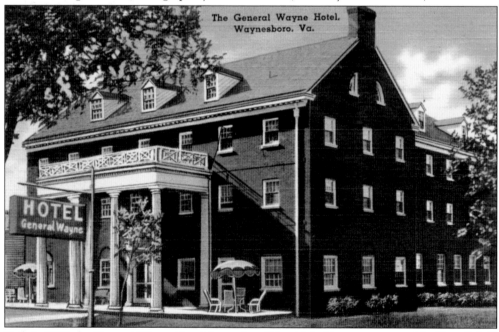

Built in 1938, the General Wayne Hotel, located on West Main Street, was named for Gen. "Mad" Anthony Wayne. It had 40 guest rooms, most of which had private baths. A room for the night cost $1.75. War bond rallies were held here during World War II. Some famous guests stayed at the Wayne, including Greer Garson, Tex Ritter, and Dwight D. Eisenhower. The building currently belongs to Fishburne Military School. (Courtesy Waynesboro Public Library.)

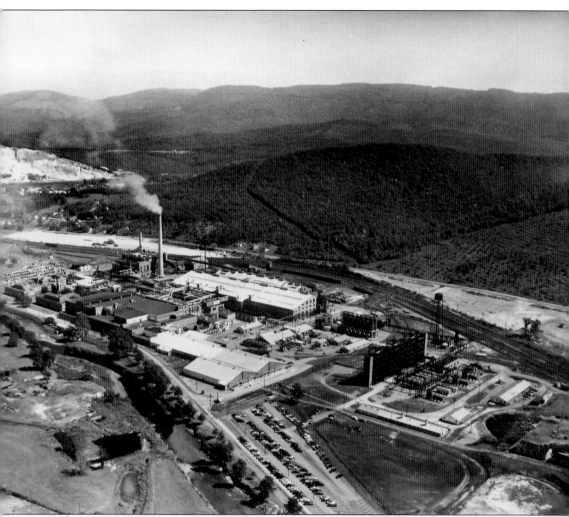

As was true in just about every community across the nation, the Great Depression hit Waynesboro hard. Fortunately for the city, DuPont had bought a large parcel of land from the Jordan Orchard company beside the South River and had built an acetate rayon plant in 1929 before the stock market crashed. After a few shaky years, the factory was going strong. New employees moved to town. The factory made good use of both the C&O and N&W lines, shipping its products out by train. By the 1960s, the Waynesboro DuPont factory had added Orlon and Lycra to its line of products. The company remained a major industry and employer in Waynesboro until Invista bought the plant and property in 2004. (Courtesy Waynesboro Public Library.)

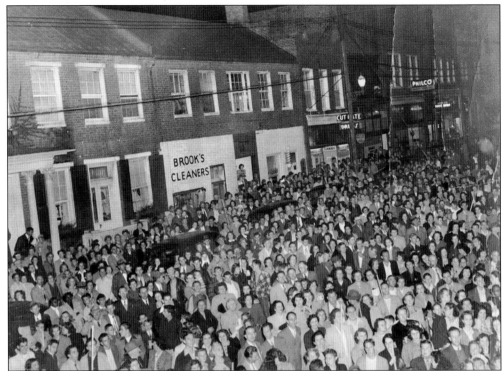

This 1950 photograph shows people gathered in downtown Waynesboro for "Silver Dollar Days," a promotional event sponsored by local merchants. People who purchased items from participating stores were then eligible to win silver dollars in a drawing. Here the anxious crowd listens to see if their names will be called. Some people hold yardsticks given away by the merchants. (Courtesy Waynesboro Heritage Foundation.)

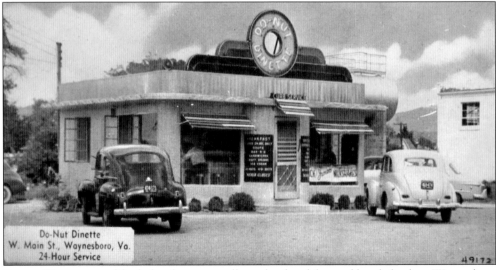

Do-nut Dinette served fresh doughnuts as well as other breakfast and lunch foods to Waynesboro customers in the 1950s and 1960s. It was located on West Main Street across from Waynesboro High School. According to the sign, they had curb service, and they "Never Closed." (Courtesy Waynesboro Heritage Foundation.)

Opened in 1911, Hamilton Cook Hardware Company stood on North Wayne Avenue to the left of an empty lot beside Mulberry Street (now Broad Street). The three-story Hamilton Cook Hardware sold fishing poles, tack, and cooking utensils, among many other things. The building burned in the 1924 fire but was rebuilt, and Hamilton Cook served Waynesboro customers until it closed for good in 1968. (Courtesy Waynesboro Pubic Library.)

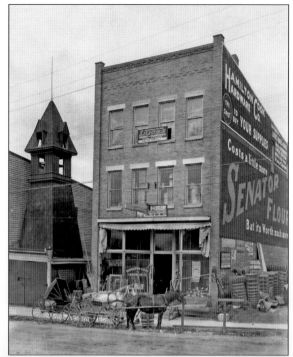

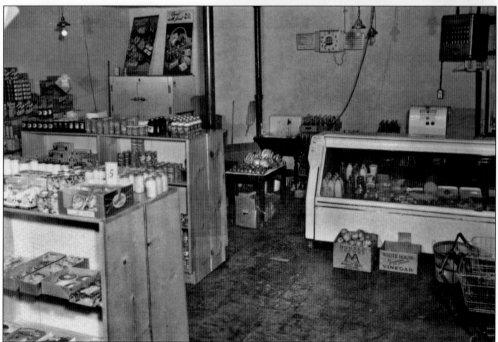

The Apple Acres store was so named because the land on which it sat along Rosser Avenue used to be apple orchards. It served as a small convenience store to neighborhood shoppers in the early to mid-1900s. This September 1953 photograph shows some of the products available—bottled milk, Rinso, bananas, Karo syrup, and boxes of macaroni. The building now houses Apple Acres Antiques. (Courtesy Waynesboro Heritage Museum.)

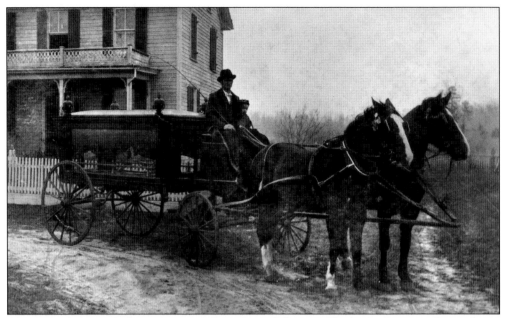

This 1900 photograph shows George S. Etter Sr. with his son Charles M. Etter in a horse-drawn hearse belonging to the family business in Stuarts Draft. In 1917, the Charles M. Etter Funeral home was built on North Wayne Avenue in Waynesboro. The business is now Etter-Reynolds Funeral Services, Inc., located at 618 West Main Street. (Courtesy Waynesboro Heritage Foundation.)

Crompton-Shenandoah was established in Waynesboro in 1927. The factory was located across the South River from the property on which DuPont was built in 1929. Crompton-Shenandoah dyed and finished gray corduroy and velveteen fabrics made at the Crompton mills in Georgia. The company prospered throughout the mid- to late 20th century and closed in the 1980s. The former Crompton building now houses several businesses and companies. (Photograph by Cortney Skinner.)

The Waynesboro National Bank, founded in 1908, was located next to Fishburne Drug Store. In 1928, the Waynesboro National Bank merged with the Citizens Bank of Waynesboro to form the Citizens-Waynesboro Bank and Trust Company. In this c. 1920 photograph, names of upstairs offices are visible in the windows, advertising Dr. A. R. Ely, Chiropractor; the E. L. Eakle Lumber Company; and Charles E. Ellison and Son, Real Estate. (Courtesy Waynesboro Public Library.)

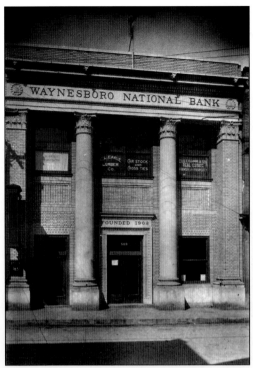

Abraham Hall on Port Republic Road served several purposes during the first half of the 20th century. A restaurant on the first floor featured musical and vaudeville acts such as "The Jolly Boys." Upstairs was a community center where dances and lodge meetings were held. Rosenwald School did not have a gymnasium at first, so it was a popular place for teenagers to play basketball. (Photograph by Cortney Skinner.)

Lacy Reid, owner of Reid's Billiard Parlor, stands in front of his establishment on North Wayne Avenue. This 1920 photograph shows the parlor sporting a patriotic, starry awning and flags, so it is possible it was around the Fourth of July. On the door, a large Coca-Cola sign is visible. Smaller signs advertise Bevo, a nonalcoholic malt beverage. Even smaller Budweiser signs are in the window, but as this was the time of Prohibition, beer was most likely not offered for sale to customers without incurring the wrath of the local law. The American Legion met on the second floor over the billiard parlor. The parlor, along with the rest of the block, burned down on December 21, 1924. (Courtesy Waynesboro Heritage Museum.)

Eight

HISTORIC HOMES

The "Old Stone House" is the oldest dwelling in Waynesboro. It was built prior to the Revolutionary War, with additions that came later. The property originally consisted of 325 acres by the South River, purchased in 1749 by John Campbell. The house walls are nearly 2 feet thick. Two underground passages were cut in the cellar walls, perhaps as escape routes in case of Native American raids. (Photograph by Cortney Skinner.)

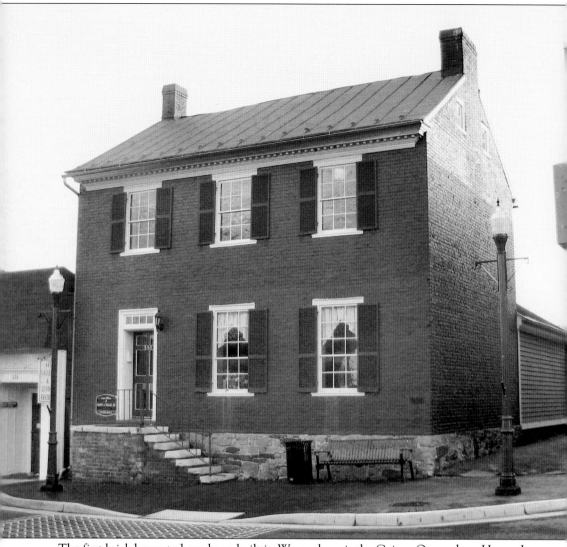

The first brick house to have been built in Waynesboro is the Coiner-Quesenbery House. It was constructed in 1806 by Caspar and Margaret Barger Coiner (Coyner) at 330 West Main Street on lot number 16 of the original tract planned out by James Flack and Samuel Estill. The Coiner family occupied the home until 1832. George and Sarah Greiner purchased the house in 1863 and lived there until their deaths nearly 50 years later. Judge C. G. Quesenbery and his brother W. D. Quesenbery took ownership of the house in 1935. It has been restored and remains the property of the Quesenbery family. (Photograph by Cortney Skinner.)

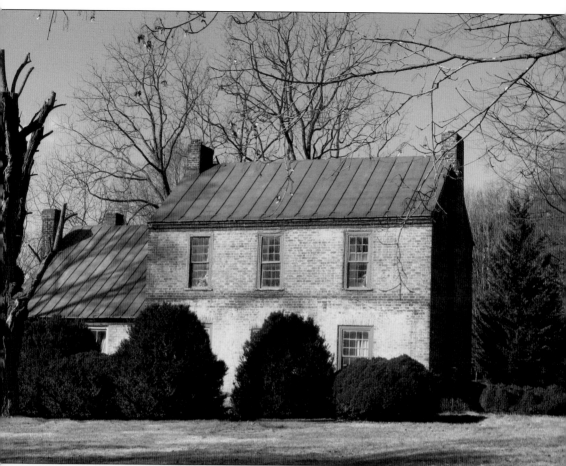

Walnut Grove is one of the four oldest homes in Waynesboro. It was built around 1810 by Archibald Stuart on a tract of land his grandfather, also named Archibald Stuart, had purchased adjacent to Joseph Tees's property in 1751. Walnut Grove was situated beside a main trail called "Greenville Road," which is the present-day Route 340. The younger Archibald Stuart was born at Walnut Grove in 1757 and became a Revolutionary War solider and later a judge. Stuart descendants lived at Walnut Grove into the mid-19th century, using the land to raise stock animals. Architect and artist William A. Pratt bought the property in 1868. He lived there until his death in 1879. The property remained in Pratt family hands until William Pratt's grandson, Julian Pratt, died in 1940. The house is now most often referred to as the Pratt House. The stream of water that runs across the south side of the property is called Pratt's Run. (Photograph by Cortney Skinner.)

The Hutcheson House was designed by architect William Delano and built by M. Mayre Ellis in 1906. This brick home is located at 472 South Wayne Avenue, across Thirteenth Street from the property on which the Brunswick Inn once stood. (Photograph by Cortney Skinner.)

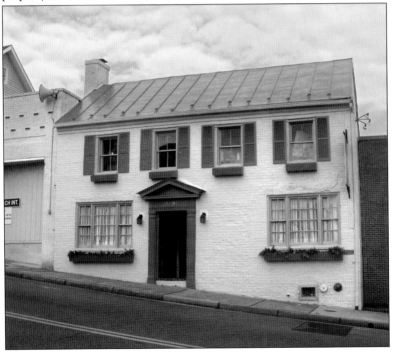

This *c.* 1835 brick home located at 533 West Main Street belonged to a Dr. Fulton and was where he lived and had his office. Dr. Fulton's home also served as a hospital during the Civil War. A mark on the house is rumored to have been made by a Union cannonball during the Battle of Waynesboro. (Photograph by Cortney Skinner.)

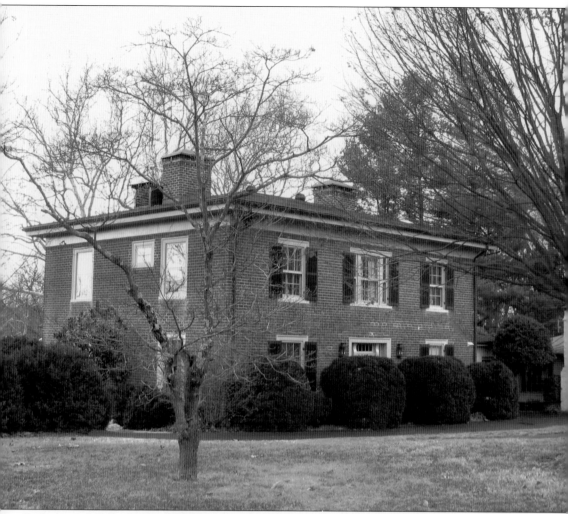

Built around 1850, the Rose Cliff house is located near the Old Stone House at the end of Oak Avenue overlooking the South River. The house was built in the Greek Revival style. It became the center of Rose Cliff Farms, a large network of Waynesboro orchards that produced and processed apples well into the 1900s. James Craig lived in the Rose Cliff house and owned the Rose Cliff Fruit Farm Company property, which encompassed many acres, including, in part, the present-day Ridgeview Park. Numerous year-round and seasonal workers tended, pruned, picked, and packed the fruit. Today the Rose Cliff house is a private residence. (Photograph by Cortney Skinner.)

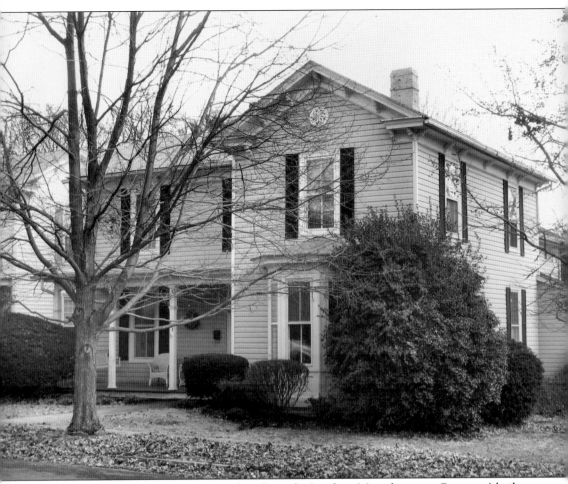

The Lambert Brothers construction firm (later the Lambert Manufacturing Company) built two Victorian-style mirror-imaged houses side by side at 620 and 628 Chestnut Avenue in 1890. This house at 628 Chestnut is the one in which carpenter John Lambert lived with his family once the house was complete. Prior to 1930, the Lamberts' daughter taught school in the second-floor bedroom on the right. Visible is the pierced chrysanthemum gable vent, a common feature on Waynesboro's Tree Street homes. The home is now owned by the Paige and Cheryl Holder family. (Photograph by Cortney Skinner.)

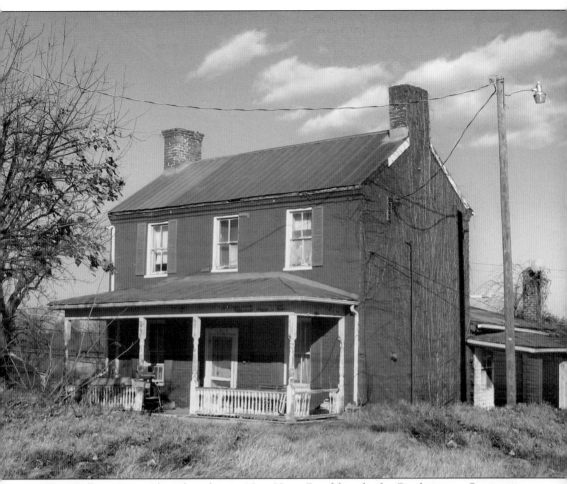

In 1819, William Brown bought a lot on New Hope Road beside the Presbyterian Cemetery for $200 and built a two-story brick house. The house served as the city's first Masonic Lodge, Waynesborough Union Lodge No. 103, which had been established in 1816 and was in need of a permanent location. The lodge was active until 1825. The house also served as the city's first school, privately run as there were no public schools in Waynesboro until the Academy was erected in 1832. In 1866, the Grand Lodge of Virginia chartered a new lodge in Waynesboro. It adopted the name Lee Lodge No. 209. Its first meeting was held in the same house that had served Union Lodge No. 103. Around 1880, Lee Lodge No. 209 moved to new quarters on North Wayne Avenue. Masons' Hall now belongs to the City of Waynesboro and is used as a private residence. (Photograph by Cortney Skinner.)

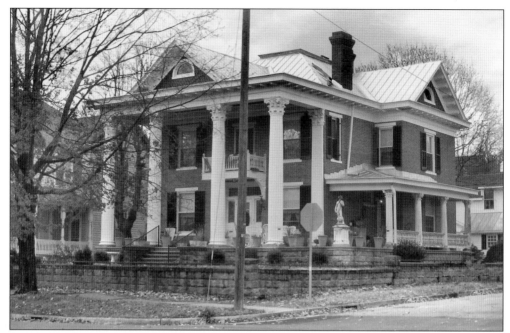

On the southwest corner of South Wayne Avenue and Twelfth Street stands the John Plumb House. Built in 1913 by John Plumb, a wealthy cattle dealer, the brick house is of the Colonial Revival style, featuring a two-story front portico with large Corinthian columns. (Photograph by Cortney Skinner.)

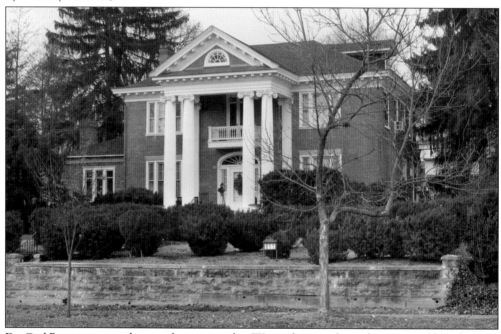

Dr. Carl Bowman was a dentist who practiced in Waynesboro in the early 1900s and later became active in the city's government. He and his wife, Nettie, designed this home on North Wayne Avenue, and it was built by M. Mayer Ellis. Today it is owned by attorney and local historian J. B. Yount III. (Courtesy Waynesboro Public Library.)

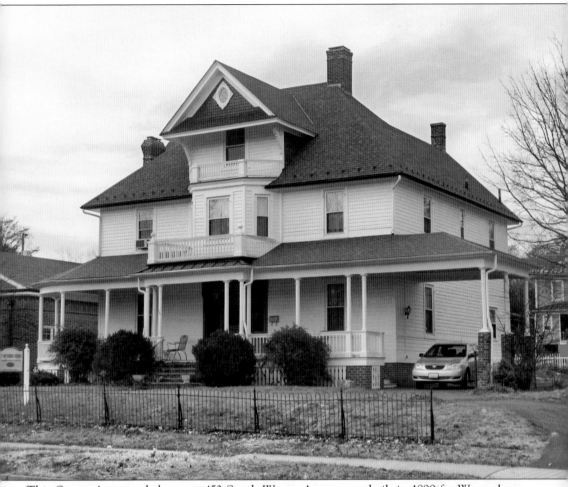

This Queen Anne–style home at 453 South Wayne Avenue was built in 1899 for Waynesboro resident and businessman Percy Loth, son of W. J. Loth, who founded the Loth Stove Company. The interior of the house was gutted by fire in 1912, but it was completely rebuilt, and in the early 1930s, the house served as Waynesboro's first hospital. Now a private residence, it is known as the Weems-Watkins Hospital, named for Dr. Bliss K. Weems and Dr. Dawson Edward Watkins, physicians who served patients at both the Wayne Avenue hospital and the new hospital built on West Main Street in 1937. (Photograph by Cortney Skinner.)

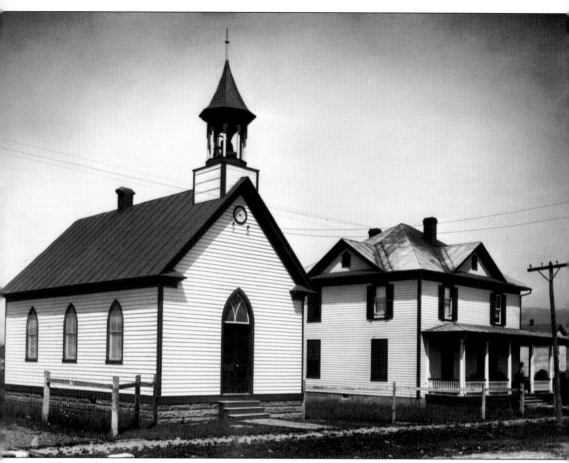

The Methodist Episcopal Church (North), also called Childress Chapel because of the generous support of the Childress family, was built in 1904 at 319 Thirteenth Street. Pastor H. A. Coffman preached to a congregation of 39. By 1917 or 1918, the church was no longer used for worship services, and in 1928, it was converted into a home. The home still stands, as does the period house to its right. (Courtesy Waynesboro Public Library.)

Nine

LEISURE TIMES

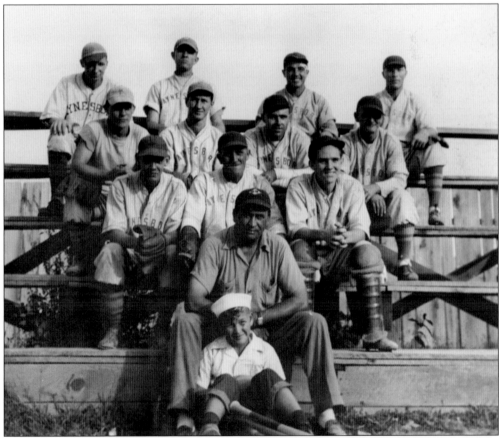

The Waynesboro Baseball Club was organized in 1923 as part of the Augusta County Baseball League. They initially played at Fishburne Military School. In 1938, the games were moved to Gateway Park, which was located at the corner of Poplar Street and Mulberry (now Broad) Street. Today the Waynesboro Generals play on the Kate Collins Middle School field. This photograph shows the 1944 team. (Courtesy Waynesboro Heritage Museum.)

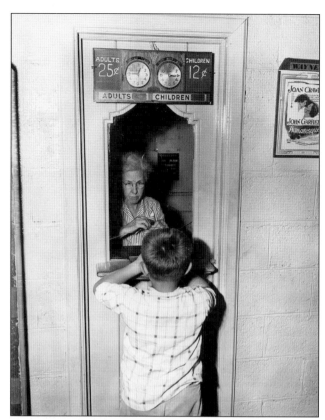

Mrs. Rupert S. Lewis sells a ticket to a young customer at the Cavalier Theater around 1946. Admission was 25¢ for adults and 12¢ for children. A poster on the wall advertises the film showing at the nearby Wayne Theater—*Humoresque*, starring Joan Crawford and John Garfield. (Courtesy Waynesboro Heritage Museum.)

To promote the new 1930 Amos and Andy film, *Check and Double Check*, these performers pose in front of the Wayne Theater in blackface in the "Fresh Air Taxicab" featured in the movie. It appears as though the actors are being presented with the key to the city. (Courtesy Waynesboro Public Library.)

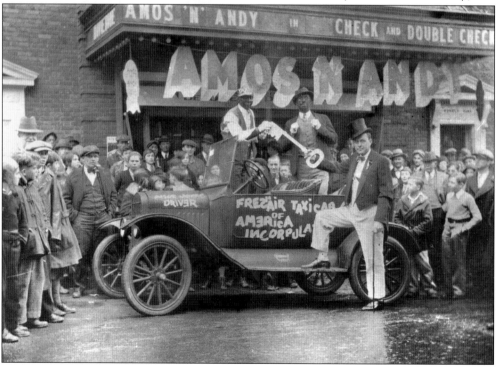

Waynesboro Girl Scouts learned new songs, nature crafts, and campfire cooking at Camp Wil-More, a day camp held in the woods between Lyndhurst Road and the South River near the present-day Kenmore Apartments. DuPont owned the land and let the Scouts use it. Here girls play an outdoor game in the summer of 1942 while two much younger children, likely the offspring of one or two of the counselors, sit on a plank bench and watch. In recalling her days as a Wil-More camper, Patsy Black (Spilman) said, "Once we got so hungry we didn't let the campfire stew finish cooking, and we ate it raw!" (Courtesy Patricia B. Spilman.)

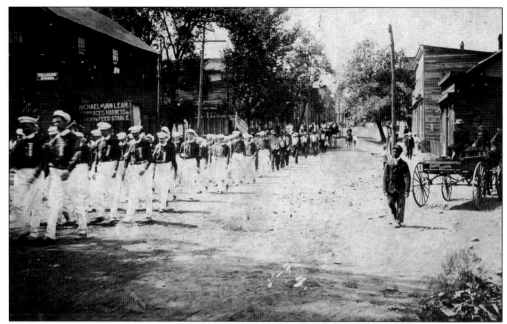

Volunteer firemen march in the 1907 Molders Union Parade. This photograph was taken on Main Street looking west toward Wayne Avenue. On the left is the shop of Michael Van Lear, who sold and repaired carriages and harnesses. On the right is a wagon advertising paperhanging. (Courtesy Waynesboro Heritage Foundation.)

In 1914, members of Boy Scout Troop 7 climbed a tree and posed for the camera on Miller's Knob, the present-day location of the Chinquapin Development. (Courtesy Waynesboro Heritage Museum.)

A Confederate rebel yell was given at the 50th anniversary reunion of the Company E, 1st Virginia Cavalry in 1911 at the Brunswick Hotel on South Wayne Avenue. Company E was formed in Waynesboro on April 19, 1861, two days after Virginia seceded from the Union. It was comprised, among others, of a number of students from the Academy. After the company was presented a Virginia flag by the town ladies, the 17 officers and 57 enlisted men left to join Col. Thomas "Stonewall" Jackson at Harpers Ferry. The veterans and citizens who gathered in 1911 at the Brunswick listened to a speech given by Congressman "Cyclone Jim" Marshall and then enjoyed a parade and a dinner. (Courtesy Waynesboro Public Library.)

During the early years of Waynesboro's Soap Box Derby, Waynesboro businessmen would open the event with their own wacky race, the "Oil Can Derby." The cars were made by the businessmen, few of whom were carpenters by trade. They used whatever was lying around, including crates and plywood, and came up with some rather curious-looking vehicles, much to the entertainment of the crowds who lined Main Street. In this 1964 photograph, *News-Virginian* president William B. Spilman, in a T-shirt and his World War II–era U.S. Marine Corps helmet, makes it to the finish line in his oilcan-adorned car. (Courtesy Patricia B. Spilman.)

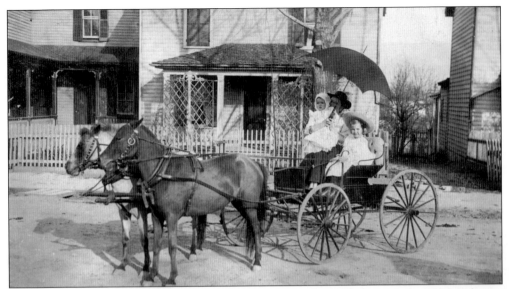

Bessie Hiserman and her children, Lyle and Edith, pose for this 1910 photograph with their horses and buggy on South Wayne Avenue, across from Fishburne Military School near what is now the Wachovia Bank. Bessie was the wife of Russell L. Hiserman, who set up his photography office in Waynesboro in 1906. (Photograph by R. L. Hiserman; courtesy Ron Hiserman.)

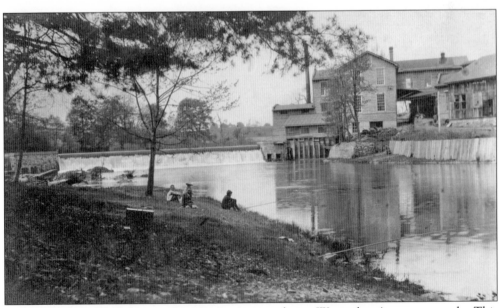

Fishing along the South River was a common pastime during Waynesboro's warmer months. This c. 1910 postcard shows people relaxing and fishing on the riverbanks across from Rife Ram and Pump Works, which was reconstructed out of concrete blocks following the 1907 fire. (Photograph by R. L. Hiserman; courtesy Ron Hiserman.)

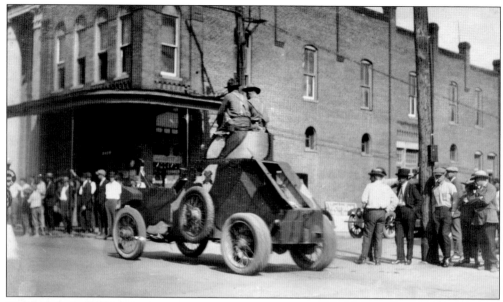

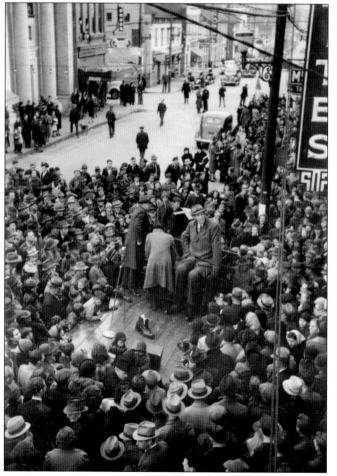

This 1925 image shows a military parade traveling west on Main Street past Fishburne Drug Store at the corner of Main Street and Wayne Avenue. The vehicle is a marine three-man King armored car, featuring an eight-cylinder engine and a turret-mounted 30-caliber machine gun. (Photograph by R. L. Hiserman; courtesy Ron Hiserman.)

Robert Wadlow, the tallest man in the world at 8 feet, 11.1 inches, visited Waynesboro on December 15, 1939. A promotional guest of White Brothers Department Store, 21-year-old Wadlow drew in huge crowds of the curious, who gathered on Main Street for a glimpse. Here Wadlow sits for a moment while children stare at his size-37 shoe. (Courtesy Waynesboro Public Library.)

The Skyline Drive-In, which opened in 1950, was located at the west end of town on West Main Street. It offered current movies and popular double features. A playground at the base of the massive screen entertained children—many dressed in pajamas should they fall asleep in their cars during the film—before the movie began. The theater closed in 1988. (Courtesy Waynesboro Public Library.)

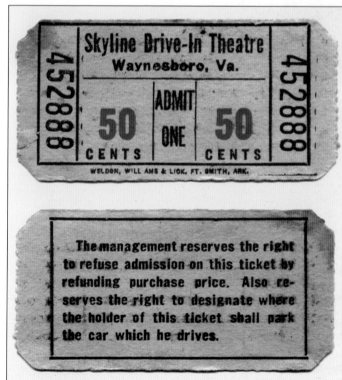

This 50¢ Skyline Drive-In ticket made it clear the management was in charge; they could not only refuse admission, but could also tell a customer where he or she would park their car. (Courtesy Waynesboro Heritage Foundation.)

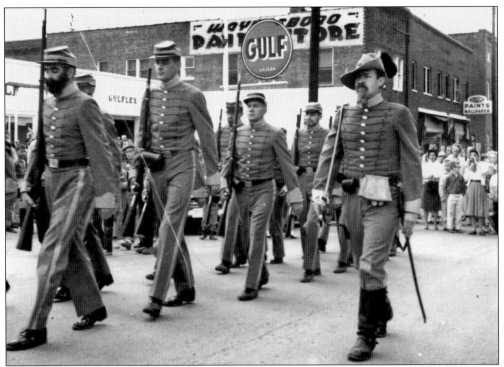

Confederate reenactors parade down West Main Street in 1961. The parade event is unidentified but could have been part of a Battle of Waynesboro commemoration. (Courtesy Waynesboro Public Library.)

This *c.* 1913 photograph shows young ladies relaxing and enjoying a game of tennis on the lawn of the Brandon Institute. The Brandon Institute was a coeducational school that was housed in the former Brandon Hotel building in Basic City. The Brandon Institute later became the all-girl Fairfax Hall. (Courtesy Waynesboro Heritage Foundation.)

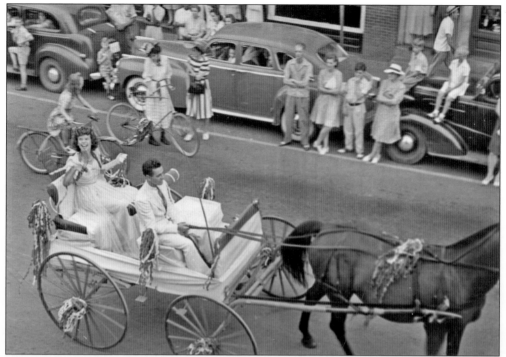

Waynesboro loves a parade, and the World War II war bond effort of the early 1940s was another good reason to march along Main Street to the applause and appreciation of the citizenry. This photograph shows Ruth Phipps, who was named the queen of Waynesboro's War Bond Parade for having sold the most war bonds in town. Phipps rides in a buggy driven by Benton Coiner. (Courtesy Waynesboro Heritage Museum.)

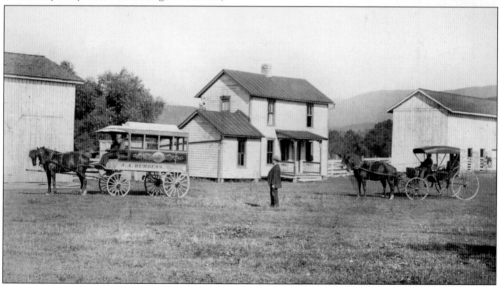

Besides comfortable rooms, elegant dining, socials, and dances, the Brunswick Inn featured picnics on the grounds, bathing in the springs near the river, and transportation for guests. This early-20th-century photograph shows a Brunswick Inn omnibus. (Courtesy Waynesboro Heritage Foundation.)

Backyard circuses and carnivals were popular activities for Waynesboro children during the first half of the 20th century. This unidentified lone boy waits for the crowds of neighborhood children to arrive to enjoy the lemonade and entertainment under the big top. The photograph appears to have been taken in a South Wayne Avenue backyard and dates to the mid- to late 1920s. The roof and steeple of Childress Chapel on Thirteenth Street can be seen in the background. (Courtesy Waynesboro Heritage Foundation.)

Ten

RISE OF THE RIVER CITY

Waynesboro's center is still the intersection of Main Street and Wayne Avenue. This 2008 photograph, looking west on Main, shows the Charles T. Yancey Municipal Building on the right where Fishburne Drug Store once stood. Past that is the Wayne Theatre, undergoing renovation. On the left is the LB&B Building, built in 1930. Beyond that is Augusta Cleaners and the old *News-Virginian* building, now vacated. The building sporting the awnings is the Waynesboro Heritage Museum. (Photograph by Cortney Skinner.)

Waynesboro's first Soapbox Derby was held on May 23, 1961. At that time, only boys were allowed to compete. The city held the races annually until 1972 and then not again until 1992, when it became a yearly event. Today the Blue Ridge Soapbox Derby Classic welcomes boys and girls to race cars down Main Street Hill in hopes of advancing to the All-American Soapbox Derby in Ohio. (Photograph by Kevin Blackburn.)

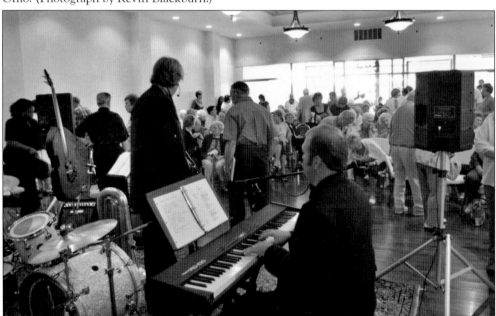

The *River City Radio Hour* is a monthly production of the Wayne Theatre Alliance. Based on the radio variety show of the 1930s and 1940s, the *Radio Hour* features a studio band, singers, musicians, comics, a dramatic serial complete with cliffhangers, and commercials for local businesses. The *Radio Hour* receives support from the Waynesboro Cultural Commission and Waynesboro Downtown Development, Inc. (Courtesy Wayne Theatre Alliance.)

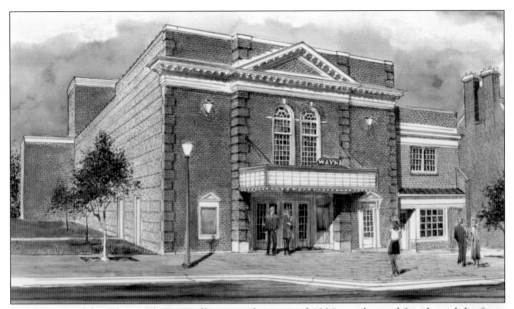

Renovation of the Wayne Theatre will restore the original 1926 neoclassical facade and the front of the 1949 annex. The work on the facades will meet the standards required by the Virginia Commission for Historic Resources and the Federal Park Service. The theater will feature a fully equipped stage, a mechanical orchestra lift, exceptional sound, and a digital projection system accommodating both live performances and movies. (Rendering by R.J. Kirchman; courtesy Wayne Theatre Alliance.)

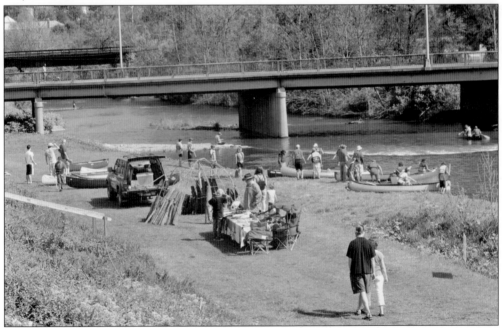

Held in April to celebrate the interdependence of the South River and the city, and to promote environmental conservation and watershed stewardship in the Shenandoah River basin, Riverfest features exhibits, an art competition, music, canoeing, and a "stream safari," which is a guided investigation of river wildlife. (Photograph by Cortney Skinner.)

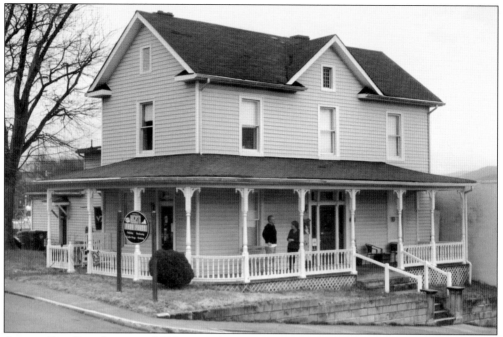

Augusta Free Press, begun in 2002, is an alternative news source featuring the *AFP* daily online news and a monthly print magazine—the *New Dominion*. This organization was a pioneer in the area, establishing an online presence even before the local newspaper had a Web site. Owned and managed by Chris and Crystal Graham, the *Augusta Free Press* is located in a *c.* 1900 house that once served as the Main Street Methodist Church parsonage. (Photograph by Cortney Skinner.)

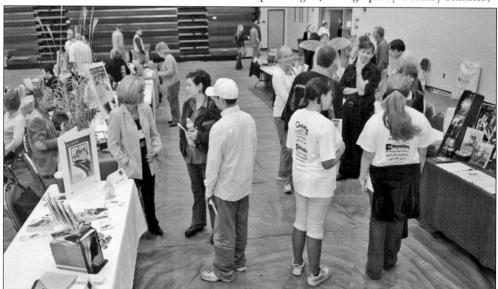

Cofounded by Waynesboro police officer and author Mark Kearney and author P. M. Terrell, Book 'Em is a literary festival held each October. Authors from across the country take part, signing books and giving talks on writing and publishing. Proceeds go to organizations dedicated to increasing literacy rates, decreasing crime rates, helping police solve crimes, and raising public awareness of the link between high illiteracy rates and high crime rates. (Photograph by Kevin Blackburn.)

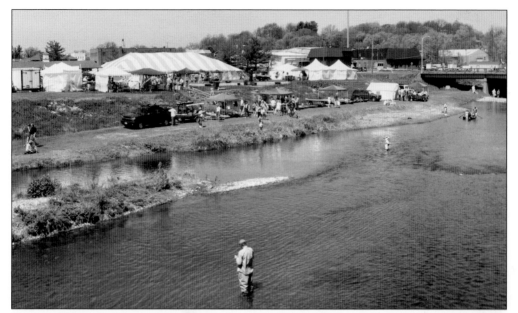

Begun in 2000, the Virginia Fly Fishing Festival is held each April on the banks of the South River in Waynesboro. It draws anglers from across the Mid-Atlantic region, offering free lectures and tips on fishing in the Old Dominion and around the globe. It also features displays, wine-tasting, and live music. (Photograph by Cortney Skinner.)

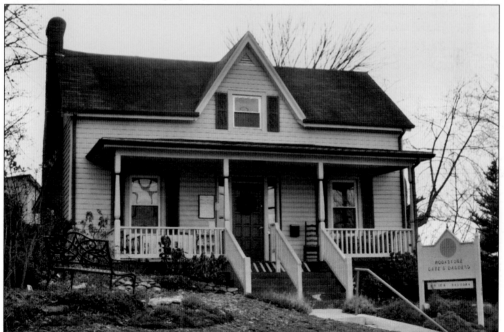

This c. 1890 house on West Main Street stands where the Confederate lines were drawn during the 1865 Battle of Waynesboro. In the backyard, the earthworks dug by Jubal Early's men are still visible. Since 2006, the house has been home to Stone Soup Café and Books, owned by Mary and Don Froelich. Stone Soup promotes local artists, writers, and musicians with art displays, workshops, and musical performances. (Photograph by Cortney Skinner.)

As Waynesboro's downtown works to renew and rebuild, the southwest side of town has become a bustling commercial area. New stores, restaurants, and hotels have sprung up along Rosser Avenue and Interstate 64. This shopping center, situated where the defunct Waynesboro Outlet Mall had been located, opened in 2008. (Photograph by Cortney Skinner.)

The Main Street Muscle Car Show, held in May, is an event offered to the public by Waynesboro Downtown Development, Inc., in conjunction with the Public Works Department, the Department of Tourism, and the Department of Parks and Recreation, as well as with businesses and sponsors. In 2008, the event drew in 4,500 people. (Photograph by Kevin Blackburn; courtesy Waynesboro Downtown Development, Inc.)

Held the third weekend in October, the Fall Foliage Festival Art Show has been a draw for artists and tourists since 1971. Approximately 200 artists from around the country and Canada display their works of fine art at this juried show. Hosted by the Shenandoah Valley Art Center, the show is run entirely by volunteers and benefits area art scholarships. (Photograph by Kevin Blackburn; courtesy Waynesboro Downtown Development, Inc.)

The Shenandoah Valley Art Center (SVAC) is located at the corner of South Wayne Avenue and Federal Street in the former Gaw Offices Building, constructed around 1915. The SVAC opened in the Mosby House atop Main Street Hill in 1986 and moved to its current location in 2007. The center offers visitors a place to enjoy and participate in a diversity of the arts through exhibits, performances, workshops, and classes. (Photograph by Cortney Skinner.)

The Artisan Center of Virginia, located in the Willow Oak Plaza on Broad Street, has been designated as the official state artisans center by the Virginia State Legislature. This private, not-for-profit organization offers unique crafts by Virginia artisans. (Photograph by Cortney Skinner.)

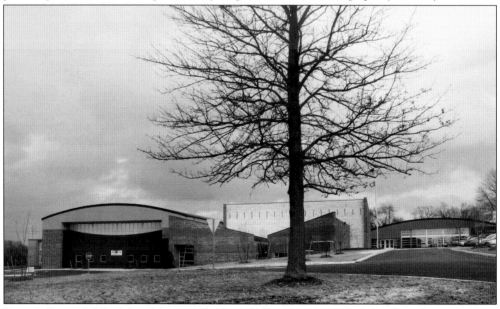

Kate Collins Middle School (originally Kate Collins Junior High School) underwent major renovations in 2008, giving the school a new auditorium and gymnasium, among other improvements. (Photograph by Cortney Skinner.)

The Waynesboro Players have been presenting performances since 1962 and continue to offer two plays and one musical annually. The Players is a nonprofit, volunteer organization that gives back to the community with a scholarship award, student participation, and open invitations for new volunteers both in front of and behind the curtains. This photograph shows the 1983 production of *The King and I*. (Photograph by Don Putnam; courtesy Waynesboro Players.)

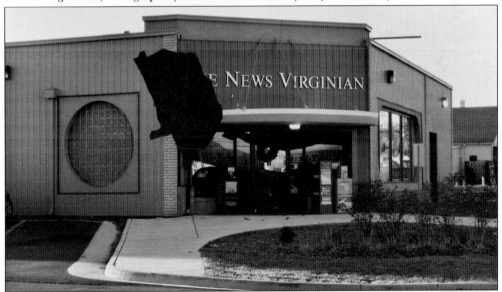

The offices of the *News-Virginian* moved from the old building at the top of Main Street Hill to the former Hassett store at 544 West Main Street in August 2005. The *News-Virginian* has been bringing local, national, and global news to Waynesboro and the Shenandoah Valley since 1929. (Photograph by Cortney Skinner.)

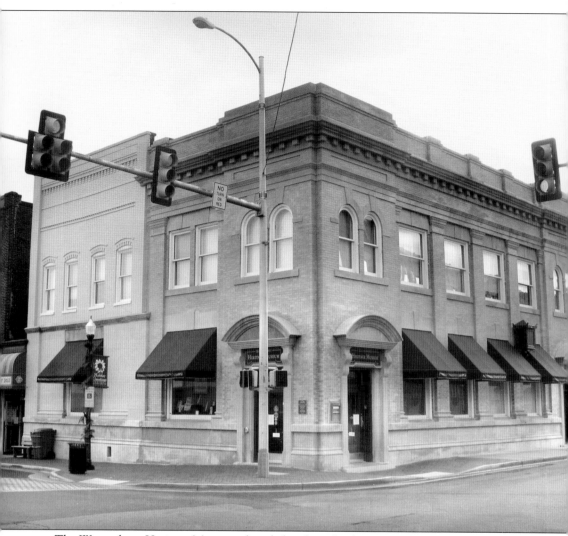

The Waynesboro Heritage Museum, founded and run by the Waynesboro Heritage Foundation, is located in the former First National Bank building at the southeast corner of Main Street and Wayne Avenue. Permanent exhibit galleries relate the city's history using wall panels and artifacts. The story begins with Waynesboro's settlement and encompasses the rich history of the city's industries, businesses, educational institutions, and more. Three to four exhibits are featured annually in the revolving exhibit gallery. (Photograph by Cortney Skinner.)

BIBLIOGRAPHY

Clark, Lillian, Howard S. Clayborne Jr., Lewis A. Lytle III, and Arlette Mason. *Waynesboro's Black Community: Historical Reflections.* Waynesboro, VA: self-published, 1992.

Bowman, Curtis. *Waynesboro Days of Yore Vol. I.* Waynesboro, VA: The McClung Companies, Inc., 1991.

———. *Waynesboro Days of Yore Vol. II.* Waynesboro, VA: The McClung Companies, Inc., 1992.

Hawke, George R. *A History of Waynesboro, Virginia to 1900.* Waynesboro, VA: Waynesboro Historical Foundation, 1997.

———. *A History of Waynesboro, Virginia, 1900–1976.* Waynesboro, VA: Waynesboro Historical Foundation, 2007.

McAlester, Virginia and Lee. *A Field Guide to American Houses.* New York City: Alfred A. Knopf, 2004.

News-Virginian. A Pictorial History of Waynesboro, Staunton, and Augusta County. Marceline, MO: D-Books Publishing, Inc., 2003.

Shutty, Michael S. Jr. *An Old House in Greenville, Virginia.* Blacksburg, VA: The McDonald and Woodward Publishing Company, 1997.

Walker, Lester. *American Shelter.* Woodstock, NY: The Overlook Press, 1981.

ACROSS AMERICA, PEOPLE ARE DISCOVERING
SOMETHING WONDERFUL. THEIR HERITAGE.

Arcadia Publishing is the leading local history publisher in the United States. With more than 5,000 titles in print and hundreds of new titles released every year, Arcadia has extensive specialized experience chronicling the history of communities and celebrating America's hidden stories, bringing to life the people, places, and events from the past. To discover the history of other communities across the nation, please visit:

www.arcadiapublishing.com

Customized search tools allow you to find regional history books about the town where you grew up, the cities where your friends and family live, the town where your parents met, or even that retirement spot you've been dreaming about.